80 Original Charms

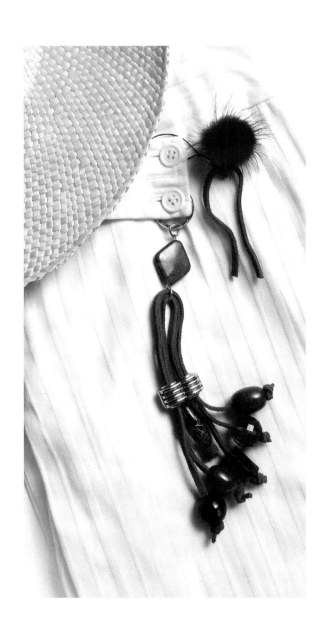

GW00568521

Contents

The pieces of jewellery presented in this book are similar to amulets, lucky charms or talismans; they enchant and captivate ... so let yourself fall under their spell. These delightful charms are designed to enrich your life while at the same time protecting you.

The idea is to add pendants, miniatures and charms on to a chain in order to create your own personalised design. These objects hold special meanings — they allow your character or personality to be deciphered in an instant, providing an evocative snapshot of your life.

There are no rules or restrictions on how to make these charms, so let your imagination go! The essential ingredients are a mixture of colours, combinations of various materials, a variety of arrangements and lots of fun.

Fastened to your bags, phones or clothes, these charms will make you stand out. Gorgeous pieces of jewellery — at an affordable price!

Martine

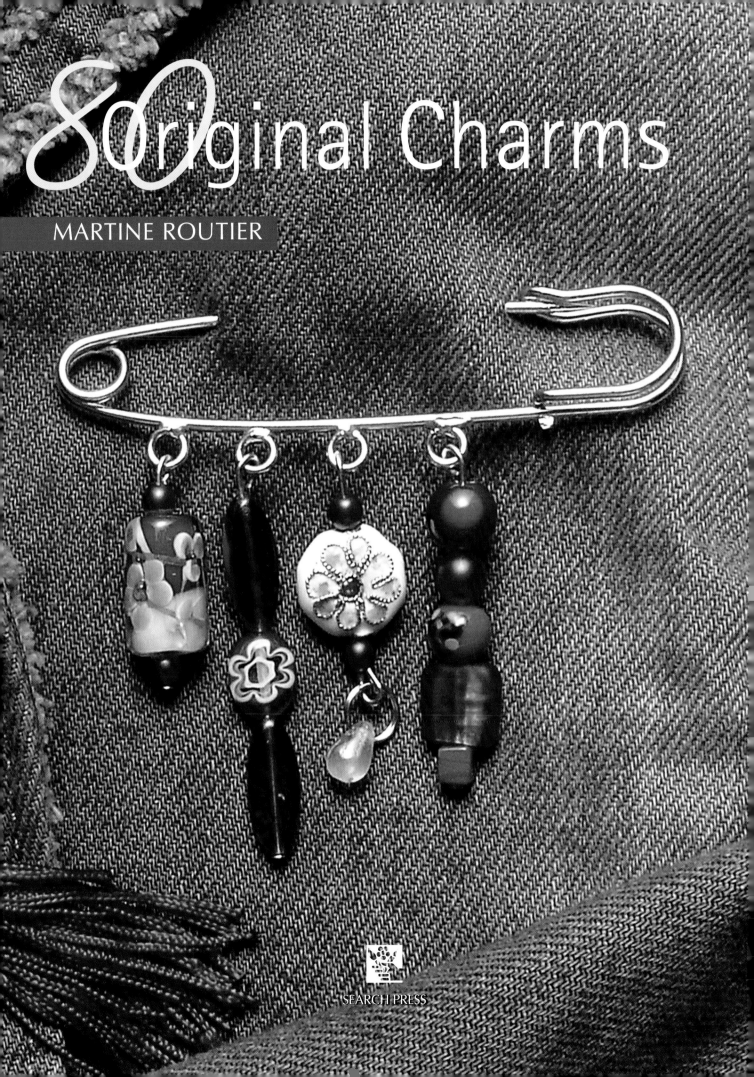

80 Original Charms

MARTINE ROUTIER

SEARCH PRESS

Materials

1 – Wire cutters
These are used to cut headpins or straight pins.

2 – Round nose pliers
These are used for making loops on headpins or straight pins.

3 – Flat nose pliers
These are used for flattening crimp beads and end-fasteners.

4 – Nylon cord
Choose elasticated cord as it is easier to use. The thickness used is 0.5mm in diameter.

5 – Cotton thread
This can be mercerised or waxed.

6 – Straight pins
These are pins on which you make a loop using the round nose pliers after threading the beads. They come in lengths of 3, 5 and 7cm.

7 – Headpins
These are identical to the straight pins apart from having a flat head at one end.

8 – Jump rings
These are made of metal (*gold, silver or copper*) and are open, closed or split to allow different objects to be inserted.

9 – Clasps
These are made of metal (*gold, silver or copper*) or coloured aluminium. They come in different sizes.

10 – Chains
These are made of metal (*gold, silver or copper*) or coloured aluminium. They come in a variety of lengths with links of different sizes.

11 – Kilt pins
These are decorative pins for fastening kilts. In gold, silver or copper, they often come with small loops from which pendants can be dangled.

12 – Mobile phone charm straps
These are available in different colours, with or without a jump ring. They fit easily to mobile phones (*see inset below*).

All of the measurements in this book are given in centimetres. To convert them to inches, multiply by 0.4.

Thread the loop of the mobile phone charm strap through the small ring located at the top of your phone using a needle. The ring may also be found in the bottom inside section of the device.

Slip the pendant into the loop of the strap and pull.

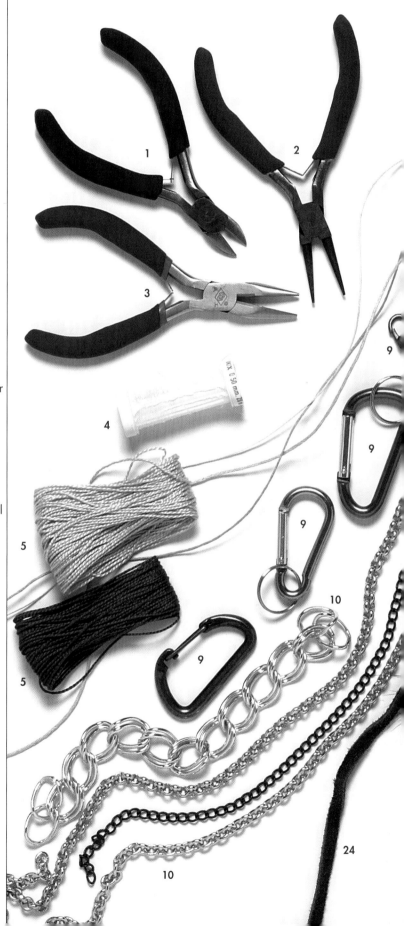

24

and supplies

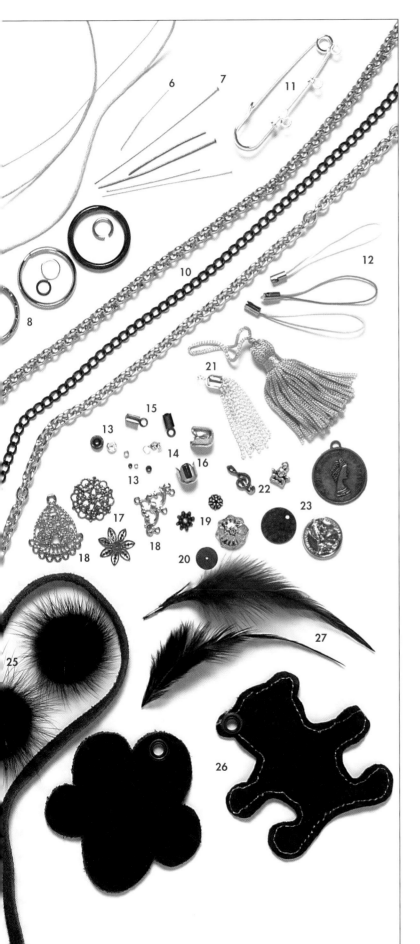

13 – Crimp beads
These are metal beads (*gold, silver or copper*) available in three sizes. They are used for securing an item (*bead, clasp, etc.*). They are squeezed using flat nose pliers.

14 – Callottes/Beadtips
These are findings (*gold, silver or copper*) used to hide the knot at the end of a string of beads.

15 – End-fasteners
These are beadtips, squeezed using flat nose pliers. They are suitable for a wide range of stringing materials (*leather thong, ribbon, cord, etc.*). Available in gold, silver or copper, and in different sizes.

16 – End caps
Cap-shaped (*gold, silver or copper*), they are used to hide the end of a string of beads.

17 – Stampings
These come in a variety of forms (*gold, silver or copper*). Their structure allows you to arrange the beads as you like using pearlised or nylon cord.

18 – Connectors
Available in different shapes and sizes, in gold, silver or copper, it is possible to dangle a number of items from them, depending on how many loops they have.

19 – Spacers
Often filigree, these enhance the beads and give them a traditional touch. They come in different shapes and sizes, in gold, silver or copper.

20 – Rondelles
These are small, round metal findings (*gold, silver or copper*) which you can add between two beads for greater elegance. Available in different sizes, they can be set with lead glass beads.

21 – Tassels
Made from silk or small chains, available in different sizes and colours, and often topped with an end cap, they finish off a composition.

22 – Charms
These are small trinkets representing different motifs (*cat, elephant, etc.*).

23 – Medals, coins or sequins
Smooth, beaten or iridescent pieces made of gold, silver or copper and used as charms.

24 – Leather thongs

25 – Mink pom-poms

26 – Nubuck or felt shapes
(*hearts, bears, flowers, etc.*).

27 – Feathers

Not included in photograph:

A pair of scissors
These are used for cutting nylon thread and leather thongs.

The beads

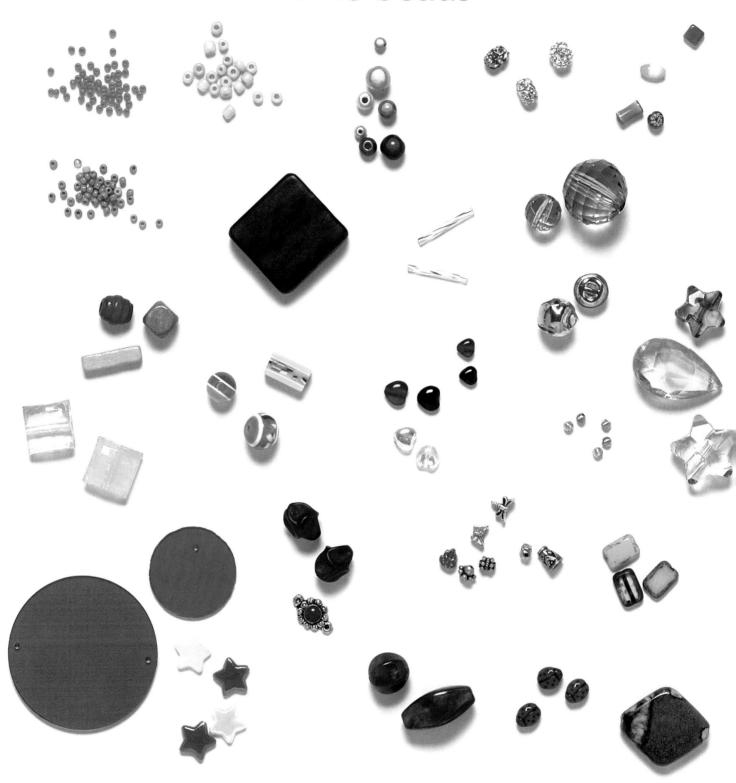

Rocaille or seed beads

These are the basic types of bead. They are mostly round but also cylindrical, and available in various sizes.

The advantages are that they come in a huge variety of colours and finishes (*pearlised, matte, metallic or opaque*), are easy to source and are affordable.

Fancy beads

These come in different shapes (*round, olive, teardrop, pear, bicone, square, tubular, cubic, cylindrical, pyramidal, heart or star shaped*), styles (*faceted, beaten, filigree, etc.*) and materials (*mother-of-pearl, wood, metal, glass, crystal, plastic, etc.*).

General information

STRAIGHT PINS AND HEADPINS

Straight pins are pins with no heads (*gold, silver or copper*).

Headpins are metal pins that are flattened at one end. Different sizes and finishes are available (*gold, silver or copper*).

Headpins are extremely versatile; they can be used to create charms.
Simply slip some beads on to the headpin, make a loop **x** and attach to any creation.

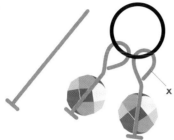

Linking. Various straight pins can be threaded with beads, looped at each end and attached to one another.

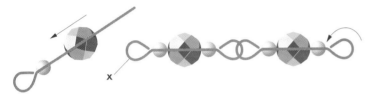

In each case, round nose pliers are an invaluable tool as they are used to make the loops **x** in the headpins and straight pins.

We recommend using small round nose pliers for making small loops.

MAKING LOOPS

Firmly grip the tip of the straight pin using the round nose pliers and twist it towards you to make a loop. (*See diagram below.*)

On a pin threaded with beads, allow 7mm (¼in) to make the loop.

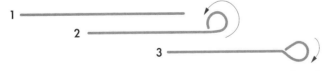

If you need a particularly long pin, you can use a piece of steel wire cut to the desired length and then make loops at each end.

CHAIN TASSELS

These metal tassels (*gold, silver or copper*) are available commercially. However, you can make them yourself by forming a cluster of small fine chains topped with an end cap.

NYLON CORD

Nylon cord is without doubt the most popular cord. It is often used when starting out in jewellery making. It requires little equipment, no pliers and no needles.

Its attractions are that it is flexible, invisible and non-allergenic. For greater flexibility and manageability, use elasticated nylon cord.

Nylon cord has two main uses: knotting and crossing.

Knotting

Simple knot. Make a loop then pass the cord through it.

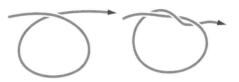

Double knot. Begin by making a simple knot then pass the cord through the same loop a second time. This knot stops the loop from coming undone.

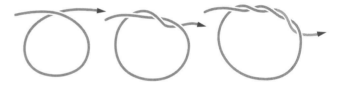

Crossing

Because it is so supple, nylon cord can be threaded and rethreaded through the beads, thus providing a wide variety of bead arrangements.

The basic principle of crossing is as follows: a strand is threaded through a bead from left to right and a second strand is threaded through the same bead from right to left.

ASSEMBLING A CRIMP BEAD

Thread crimp bead **A** on to a length of nylon cord (*diagram 1*). Pass the end of the cord through ring **B**, then back into crimp bead **A** (*diagram 2*). Flatten the crimp bead using flat nose pliers (*diagram 3*).

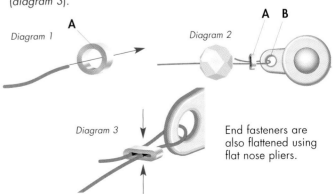

Diagram 1

Diagram 2

Diagram 3

End fasteners are also flattened using flat nose pliers.

Romantic

CARMEN

Length: 12cm (4¾in)

1 x 2.5cm split ring **a** (silver)
1 x 0.5cm open jump ring **b** (silver)
8 x 0.3cm open jump rings **c** (silver)
5 x 4cm long chains (silver)
3 charms in the shape of a sun, chilli pepper and bear (silver)
1 connector with 5 loops in the shape of an Inca mask (silver)

Attach **b** to **a**.
Take the chains and attach them to **b**.
Attach jump rings **c** to the other ends of the chains and fix them to the top of the connector. Attach the three charms to the bottom using jump rings **c** (*see diagram*).

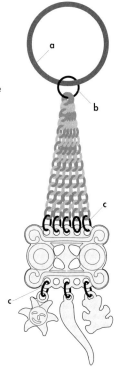

BIANCA

Length: 31.5cm (12½in)

1 x 26cm long chain (silver)
2 x 2.5cm split rings **a** (silver)
2 x 0.7cm open jump rings **b** (silver)
3 x 0.3cm open jump rings **c** (silver)
1 x 4cm long clasp **d** (silver)
1 tassel **e** (silver)
3 sequins (silver): 2 x 1.5cm, 1 x 2cm

Attach one **a** and one **b** to each end of the chain.
Next attach **d** to one end and **e** on to **b** at the other end.
Finally, attach the sequins to the chain (*see diagram*).

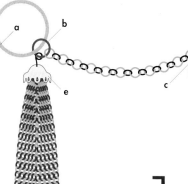

JULIE

Length: 9.5cm (3¾in)

1 mobile phone charm strap (white)
6 x 0.3cm open jump rings **c** (silver)
6 sequins (silver): 3 x 1.5cm **f**, 3 x 2cm **g**
1 x 0.7cm closed jump ring **h** (silver)
2 x 1.5cm long links of a chain **i** (silver)

Attach **h** to the mobile phone charm strap and then the links **i** to **h**.
Take the sequins and attach one **c** to each of them. Next, fix one **f** and one **g** to **h** and then one **f** and one **g** to each link **i**.

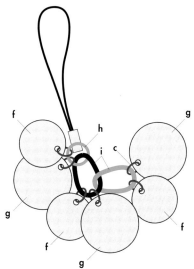

ISABELLE

Length: 9 cm (3½in)

1 mobile phone charm strap (black)
1 x 0.7cm closed jump ring **a** (silver)
2 x 0.5cm open jump rings **b** (silver)
2 charms in the form of a cupid and a flower (silver)
1 leaf-shaped connector with 2 loops (silver)

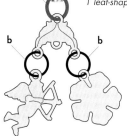

Attach **a** to the mobile phone charm strap then attach the connector to **a**.
Assemble the two charms on to the connector using the two **b**.

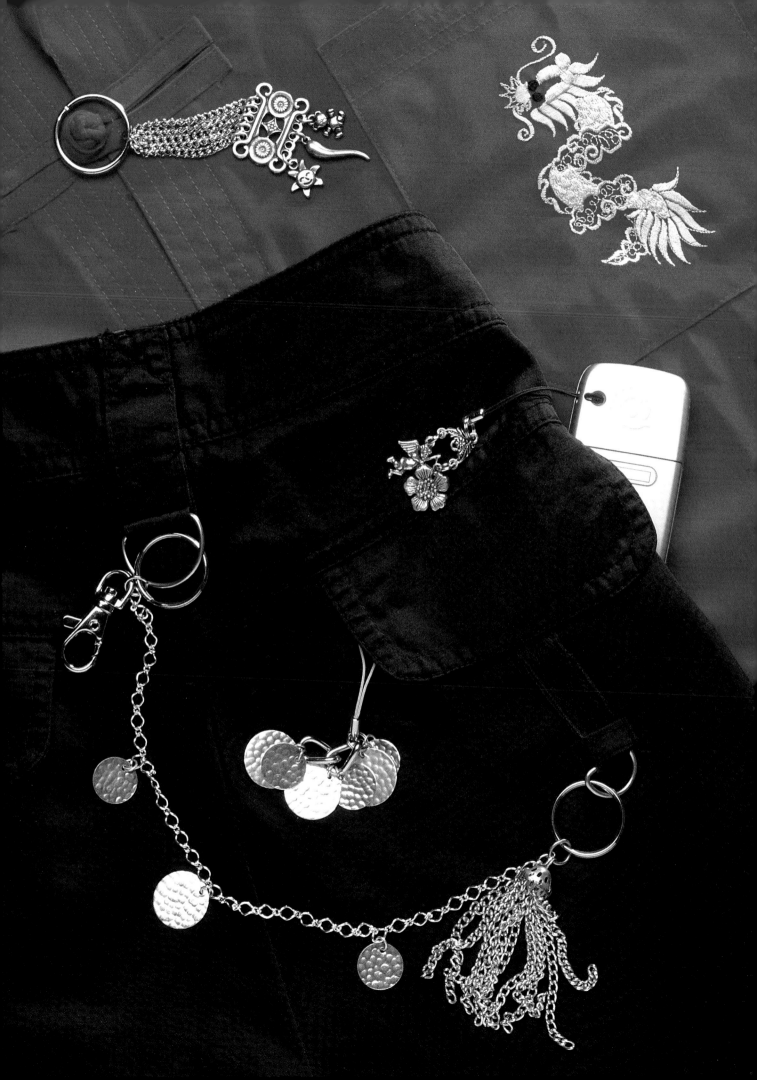

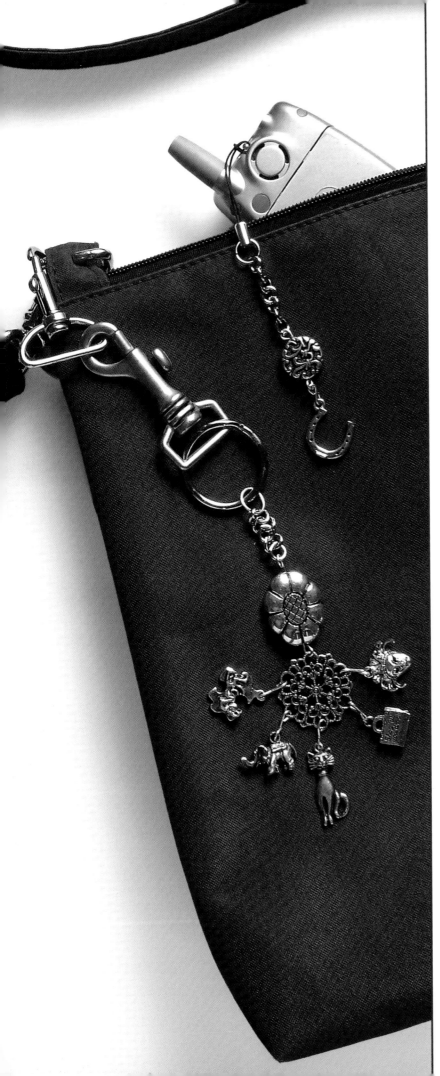

ELISA

Length: 20cm (7¾in)

1 x 5.5cm long clasp **a** (silver)
1 x 2.5cm split ring **b** (silver)
1 x 0.7cm open jump ring **c** (silver)
1 x 3cm long chain **d** (silver)
1 x 4.5cm long straight pin **e** (silver)
1 x 2.5cm long flower-shaped fancy bead **f** (silver)
1 x 2.5cm diameter filigree stamping **g** (silver)
5 x 2cm long straight pins **h** (silver)
5 charms in the shape of a mask **i**, bag **J**, cat **k**, elephant **L**, 'love' **m** (silver)

Attach **b** to **a**, **c** to **b** then **d** to **c**.

Take **e** then make a loop at one end using round nose pliers. Attach it to **d** and then insert it into **f**. Make a loop at the other end, then attach **g** to it.

Take the five **h** and make a loop at one end of each in order to fix them around **g** (*see diagram alongside*). Make a loop at the other end from which to hang the charms (**i**, **j**, **k**, **L**, **m**).

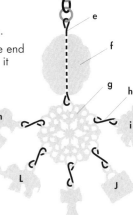

AMANDA

Length: 12.5cm (5in)

1 mobile phone charm strap (black)
1 x 0.8cm closed jump ring **n** (silver)
1 x 2.5cm long chain **o** (silver)
1 x 3cm long straight pin **p** (silver)
1 x 1.3cm diameter flat fancy bead **q** (silver)
1 x 1cm long straight pin **r** (silver)
1 charm in the shape of a horseshoe **s** (silver)

Attach **n** to the mobile phone charm strap then **o** to **n**.

Take **p** and make a loop at one of its ends using round nose pliers in order to attach it to **o**. Next insert it into **q**, then make a loop at the other end.

Make a loop at one end of **r** and attach it to the end of **p**.
Make a loop at the other end of **r** and fasten **s** on to it.

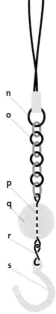

Juliet

Length: 16.5cm (6½in)

1 x 2.5cm split ring **a** (silver)
1 x 0.7cm open jump ring **b** (silver)
4 x 0.5cm open jump rings **c** (silver)
9 x 2cm long straight pins (silver)
2 x 2.5cm long headpins (silver)
1 x 0.7cm long cone-shaped fancy bead **d** (silver)
1 x 1.3cm long disc-shaped fancy bead **e** (silver)
1 x 0.6cm long olive-shaped fancy bead **f** (silver)
4 cylindrical-shaped fancy beads,
 0.5cm long and 0.5cm diameter **g** (silver)
1 x1.5cm long charm in the shape of a bell
 h (silver)
1 round connector with 3 loops (silver)
2 round pendants with 2 loops **i** (silver)
2 olive-shaped ridged beads, 1.4cm long
 and 1cm diameter **j** (silver)
4 x 0.3cm rocaille beads **k** (red)
2 fancy beads in the shape of a double pyramid
 measuring 1cm on each side **L** (silver)

Attach **b** to **a**.

Section n°1: take three straight pins and
thread through **d**, **e** and **f**.
Make a loop at each end using round nose
pliers and link these three pins together.

Section n°2: attach one **i** to one **c**. Thread
one **L** on to a straight pin, make the loops
and then attach the section to **i**.

Take a headpin, pass it through one **k**, one **j**
and one **k**. Make a loop and attach the
whole section to the previous pin (see
diagram). Repeat this process once more.

Section n°3 : take four straight pins and
thread one **g** on to each. Make the
loops and then link the pins together.
Attach one **c** to one end.
Fasten **h** to the other end using one **c**.

Attach section n°1 to **b**, the n°2
sections to the two side loops of the
connector and section n°3 to
the central loop (see diagram).

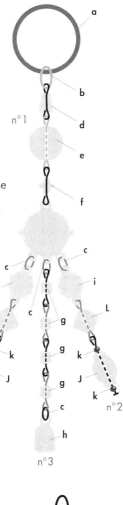

Helen

Length: 12cm (4¾in)

1 mobile phone charm strap (red)
1 x 0.7cm closed jump ring **x** (silver)
1 heart-shaped connector with 3 loops (silver)
3 x 2.5cm straight pins (silver)
3 x 1.5cm headpins (silver)
3 x 0.7cm cone-shaped fancy beads **d** (silver)
3 cylindrical fancy beads, 0.5cm long
 and 0.5cm diameter **g** (silver)
1 round pendant with 2 loops **i** (silver)
6 x 0.3cm rocaille beads **k** (red)

Attach jump ring **x** to the mobile phone
charm strap.

Section n°1: thread one **k**, one **g** and one
k (A) on to one straight pin. Make a loop
at each end with round nose pliers. Thread
one **d** on to one headpin (B). Make a loop
at the end and link A and B together.
Repeat once.

Section n°2 : repeat the process, but
insert **i** between A and B. Fix the two n°1
sections to the side loops of the connector and
the n°2 section to the central loop (see diagram).

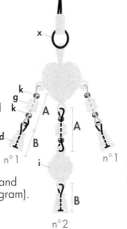

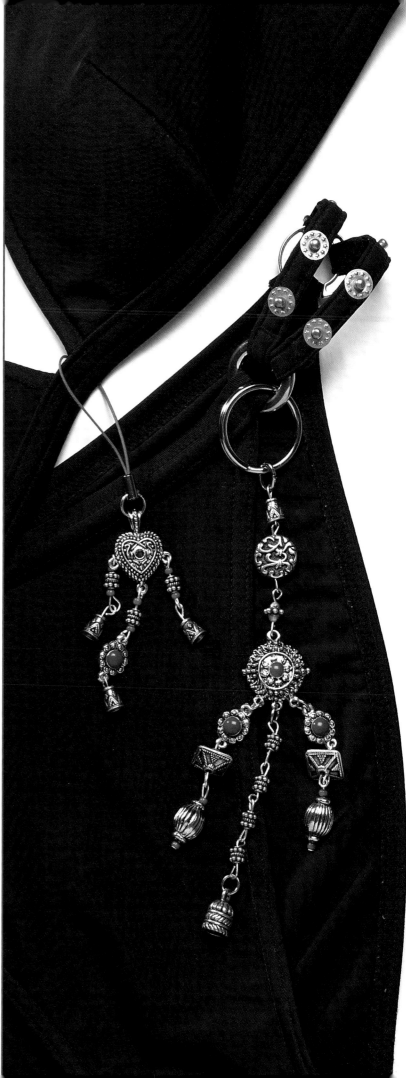

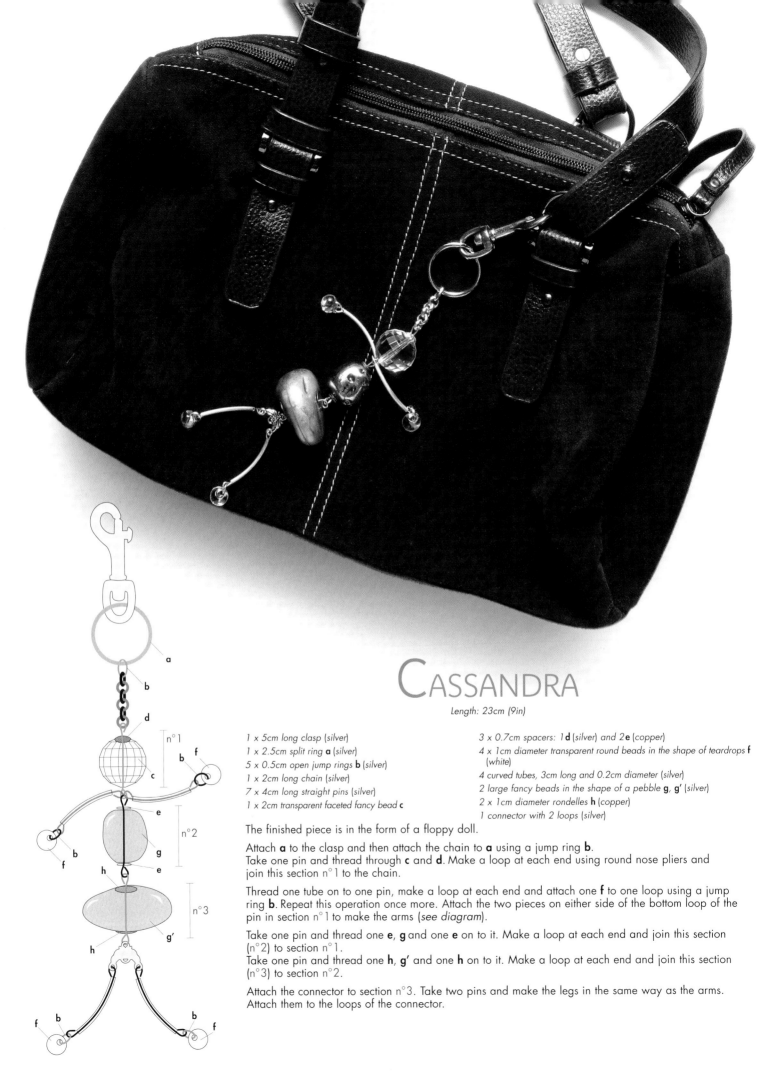

CASSANDRA

Length: 23cm (9in)

1 x 5cm long clasp (silver)
1 x 2.5cm split ring **a** (silver)
5 x 0.5cm open jump rings **b** (silver)
1 x 2cm long chain (silver)
7 x 4cm long straight pins (silver)
1 x 2cm transparent faceted fancy bead **c**

3 x 0.7cm spacers: 1**d** (silver) and 2**e** (copper)
4 x 1cm diameter transparent round beads in the shape of teardrops **f** (white)
4 curved tubes, 3cm long and 0.2cm diameter (silver)
2 large fancy beads in the shape of a pebble **g**, **g'** (silver)
2 x 1cm diameter rondelles **h** (copper)
1 connector with 2 loops (silver)

The finished piece is in the form of a floppy doll.

Attach **a** to the clasp and then attach the chain to **a** using a jump ring **b**.
Take one pin and thread through **c** and **d**. Make a loop at each end using round nose pliers and join this section n°1 to the chain.

Thread one tube on to one pin, make a loop at each end and attach one **f** to one loop using a jump ring **b**. Repeat this operation once more. Attach the two pieces on either side of the bottom loop of the pin in section n°1 to make the arms (*see diagram*).

Take one pin and thread one **e**, **g** and one **e** on to it. Make a loop at each end and join this section (n°2) to section n°1.
Take one pin and thread one **h**, **g'** and one **h** on to it. Make a loop at each end and join this section (n°3) to section n°2.

Attach the connector to section n°3. Take two pins and make the legs in the same way as the arms. Attach them to the loops of the connector.

CHLOE

Length: 12.5cm (5in)

1 mobile phone charm strap (white)
1 x 0.7cm closed jump ring **i** (silver)
3 x 2cm long straight pins (silver)
4 x 3.5cm long headpins (silver)
1 x 1.2cm transparent faceted round bead **J** (white)

8 tubular beads, 1cm long and 0.4cm diameter **k** (silver)
1 tubular bead, 1cm long and 0.8cm diameter **L** (silver)
8 x 0.3cm transparent rocaille beads **m** (white)
1 fancy bead in the shape of a pebble **n** (silver)

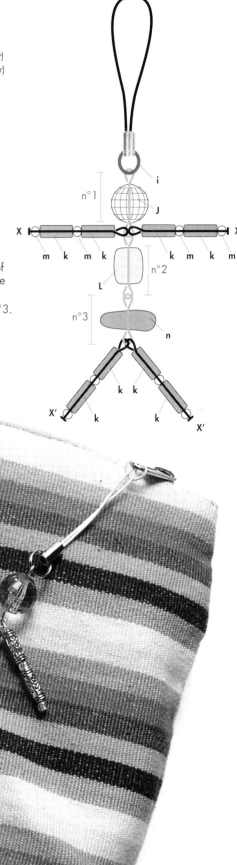

The finished piece takes the form of a floppy doll.

Attach **i** to the mobile phone charm strap.

Take one straight pin and thread through **J**. Make a loop at each end using round nose pliers, then join this section n°1 to **i**.

Take one straight pin and thread through **L**. Make a loop at each end and attach this section (n°2) to n°1.
Take one straight pin and thread through **n**. Make a loop at each end and attach this section (n°3) to n°2.

Take one headpin and thread through one **m**, one **k**, one **m** and one **k**. Make a loop at the end of the headpin. Repeat this process once more. Join the two pieces to the top of section n°2 to make the arms **X** (*see diagram*).

Take two headpins and make the legs **X'** in the same way as the arms. Join them on to section n°3.

VALENTINA

Length: 10.5cm (4¼in)

1 mobile phone charm strap (red)
1 x 0.5cm open jump ring **c** (silver)
3 x 1.5cm long headpins (silver)
9 x 2.5cm long straight pins (silver)
4 heart-shaped beads (black): 2 x 0.7cm **e**, 2 x 0.5cm long **e'**
4 x 0.5cm long heart-shaped beads **f** (silver)
4 transparent heart-shaped beads (red): 22 x 0.7cm **g**, 2 x 0.5cm long **g'**

Attach jump ring **c** to the mobile phone charm strap.

Take three headpins and attach one **g** to one, one **e** to another and one **e'** to the last one.
Thread the other beads on to the straight pins.
Make loops at the ends of the headpins and straight pins using round nose pliers.

Join the sections together as shown in the diagram.

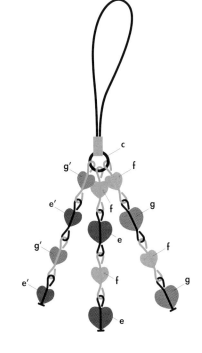

LEAH

Length: 25cm (9¾in)

1 x 2.5cm closed jump ring **a** (silver)
7 chains: 1 x 1.5cm, 1 x 3cm, 2 x 5.5cm, 1 x 6cm, 1 x 7.5cm, 1 x 11cm long (silver)
1 x 4.5cm long fancy chain with large links **x** (silver)
1 x 0.7cm open jump ring **b** (silver)
16 x 0.5cm open jump rings **c** (silver)
7 x 1.7cm long faceted beads in the shape of a teardrop **d** (red)
2 x 1.5cm long headpins (silver)
9 x 2.5cm long straight pins (silver)
11 heart-shaped beads: 4 x 0.7cm **e** (black) and 7 x 0.5cm long **f** (silver)
1 x 4cm long transparent faceted heart-shaped pendant (red)

Attach fancy chain **x** to **a** and fix the pendant on to it using **b**.

Take the seven chains and attach fourteen **c** to their ends.
Attach one **d** to one end of each chain and fix them to **a** at the other end.

Take three straight pins and attach one **e** to each.
Attach one **e** to one of the headpins.
Make loops at the ends with round nose pliers.
Join the pieces together on one jump ring **c** with the headpin at the end. Attach everything to **a**.

Proceed in the same way with six straight pins, one headpin and seven **f** (see diagram).

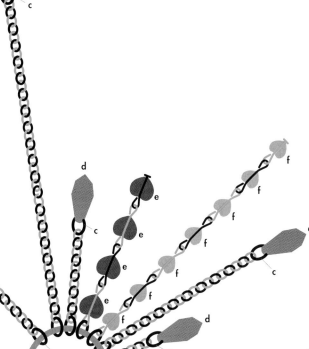
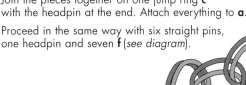

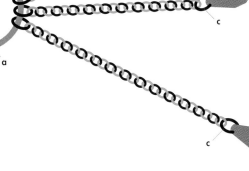

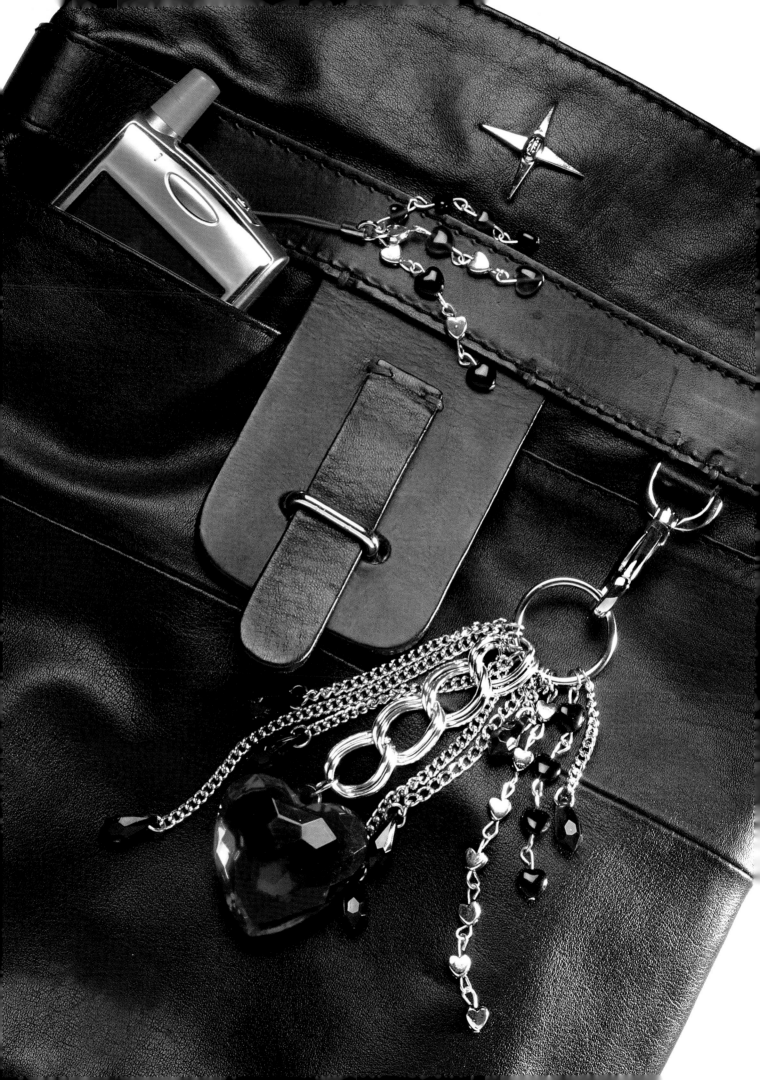

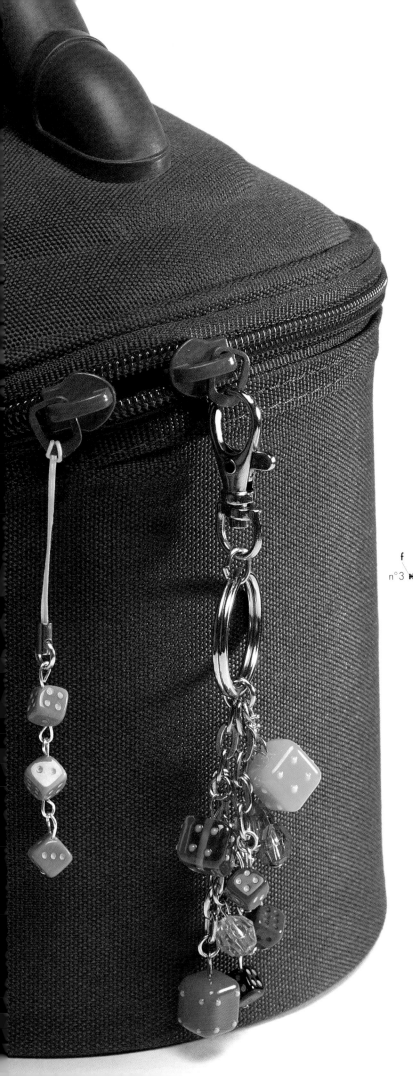

GERRY

Length: 15cm (6in)

1 x 3.5cm long clasp (silver)
*1 x 2.5cm closed jump ring **a** (silver)*
*13 open jump rings (silver) : 22 x 0.5cm **b** and 11 x 0.3cm **c***
*2 chains with large links **d** and **d'** measuring 3 and 6cm long (silver)*
*1 x 5.5cm long tight-linked chain **e** (silver)*
*10 headpins: 7 x 1.5cm **f** and 3 x 2cm **g** long (silver)*
*7 fancy beads in the shape of dice: 3 x 1cm on each side (blue **h**, red **i**, green **J**)*
* and 4 x 0.7cm on each side (green **k**, blue **L**, red **m**, black **n**)*
*3 x 1cm round transparent faceted beads (yellow **o**, red **p**, green **q**)*

Attach **b** to the clasp then **a** to **b**.

Section n°1 : attach **h** to one headpin **g**, **k** to one **f**, **o** to one **f**, **i** to one **g**.
Make a loop at the end of each headpin. Attach each piece to one **c** and then fasten them to chain **d'** (*see diagram*).

Section n°2 : attach **J** to one headpin **g**, **p** to one **f**, **L** to one **f**.
Make a loop at the end of each headpin. Attach each piece to one **c** and then fix them to chain **d**.

Section n°3 : attach **q** to one headpin **f**, **m** to one **f**, **n** to one **f**.
Make a loop at the end of each headpin.
Attach each piece to one **c** and then fasten them to chain **e**.
Fix this chain to one **c**.

Attach sections n°1, 2 and 3 to the second jump ring **b** and then attach this to **a**.

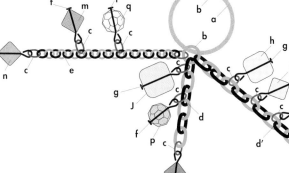

JENNIFER

Length: 10cm (4in)

1 mobile phone charm strap (fluorescent green and yellow)
*1 x 0.5cm open jump ring **b** (silver)*
2 x 2cm long straight pins (silver)
*1 x 2cm long headpin **g** (silver)*
*3 fancy beads in the shape of dice measuring 0.7cm on each side (green **k**)*

Attach **b** to the mobile phone charm strap.

Thread two **k** on to the two straight pins and one **k** on to headpin **g**.

Make loops at the ends using round nose pliers.
Join the pieces to one another and then fasten the section to **b** (*see diagram*).

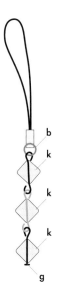

JANICE

Length: 18cm (7in)

1 x 5cm long clasp (green)
1 x 2cm closed jump ring (silver)
1 x 2cm long chain (silver)
8 open jump rings (silver): 4 x 0.3cm **a** and 4 x 0.6cm **b**
3 transparent disc-shaped pendants, diameter: 10cm **c** (yellow), 5cm with 2 holes **d** (red) and 3cm **e** (magenta)
4 x 1.5cm diameter pierced fancy pendants **f** (multicoloured)

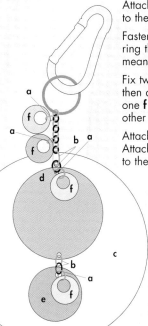

Attach the closed jump ring to the clasp.

Fasten the chain to the closed jump ring then two **f** to the chain by means of two **a**.

Fix two **b** to the end of the chain, then attach **c** to one jump ring, one **f** (using one **a**) and one **d** to the other jump ring (*see diagram*).

Attach two **b** to the other hole in **d**. Attach **e** and one **f** (using one **a**) to the second **b**.

YVONNE

Length: 9 cm (3½in)

1 mobile phone charm strap (pink)
1 x 0.5cm open jump ring (silver)
1 x 0.8cm long nugget-shaped bead (silver)
1 crimp bead (silver)
1 x 5cm length of nylon cord
1 x 3cm diameter disc-shaped transparent pendant (magenta)

Attach the jump ring to the mobile phone charm strap.

Thread the nylon cord through the pendant.
Fold the cord in two.
Thread both strands through the nugget and then into the crimp bead.
Pass them through the ring and back through the crimp bead.
Flatten the bead using the flat nose pliers.

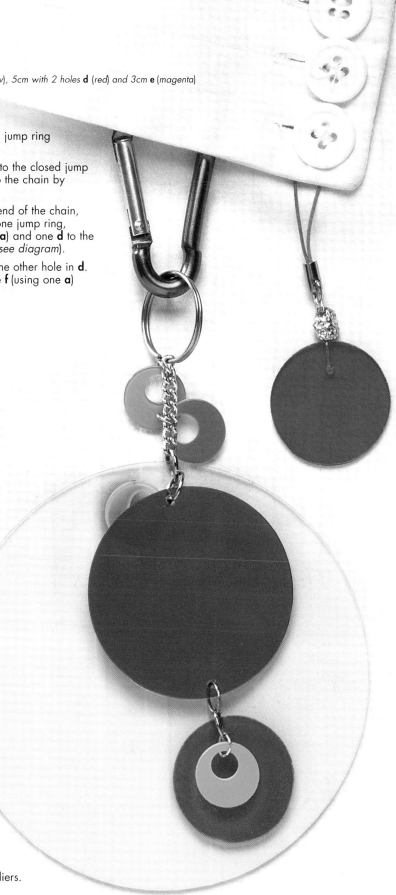

ALISON

Length: 17cm (6¾in)

1 x 2.5cm long clasp (*silver*)
1 x 2.5cm split ring **a** (*silver*)
5 open jump rings (*silver*) : 1 x 0.7cm **b** and 4 x 0.3cm **c**
5 straight pins, 2, 2.5, 3, 4.5 and 5cm long **d, e, f, g, h** (*silver*)
3 headpins : 2 x 2cm long **i** and **J** and 1 x 2.5cm long **k** (*silver*)
6 lead glass rondelle beads: 2 x 0.5cm diameter **L**, 4 x 0.4cm diameter **m**
1 transparent rectangular bead measuring 1 x 2.5cm **n** (*blue*)
3 x 0.5cm round speckled beads **o** (*silver*)
1 x 2.5cm disc-shaped bead **p** (*blue*)
1 x 0.7cm diameter round lead glass bead **q**
1 connector with 3 loops (*silver*)
2 x 0.5cm long nugget-shaped beads **r** (*silver*)
4 x 0.3cm ridged beads **s** (*silver*)
2 x 0.6cm round fancy beads **t** (*blue with patterns*)
1 cylindrical bead, 0.8cm long and 0.4cm diameter **u** (*blue*)
1 olive-shaped bead, 0.8cm long and 0.4cm diameter **v** (*blue*)
1 x 0.8cm long transparent oval bead **w** (*blue*)
1 square bead measuring 0.5cm on each side **x** (*blue*)

Attach **b** to **a** and then the clasp to **b**.
Take pin **g**, thread on to it one **L**, **n**, one **L** then make a loop at the ends using round nose pliers (n°1).

Take pin **h**, thread on to it **q**, **p** and one **o**, then make a loop at each end (n°2).

Take the connector then insert one **c** through its top loop and through each of the bottom three loops.
Thread one **m**, one **t**, one **m** on to pin **d**,
one **o**, **u**, one **o** on to headpin **k**,
one **r**, **v**, one **r** on to pin **f**,
one **m**, one **t**, one **m** on to headpin **i**,
one **s**, **w**, one **s** on to pin **e**,
one **s**, **x**, one **s** on to headpin **J**.

Make a loop at each end and then attach each piece to the connector, as shown in the diagram (n°3).

Attach n°1, n°2 and n°3 to **b**.

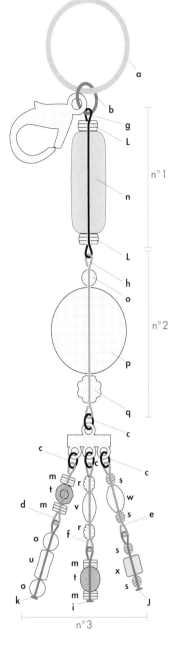

MANDY

Length: 12cm (4¾in)

1 mobile phone charm strap (*blue*)
1 x 0.7cm closed jump ring **a** (*silver*)
2 straight pins (*silver*) : 1 x 3cm **f** and 1 x 3.5cm long **f'**
1 x 2cm long headpin **i** (*silver*)
1 x 0.5cm round speckled bead **o** (*silver*)
1 x 0.5cm disc-shaped bead **p'** (*blue*)
1 x 0.7cm round lead glass bead **q**
2 x 0.5cm long nugget-shaped beads **r** (*silver*)
2 x 0.3cm ridged beads **s** (*silver*)
1 cylindrical bead, 0.8cm long and 0.4cm diameter **u** (*blue*)
1 square bead measuring 0.5cm on each side **x** (*blue*)

Attach ring **a** to the mobile phone charm strap.

Take pin **f'** and then thread on to it **q**, **p'** and **o**.

Take pin **f** and thread it through one **r**, **u**, one **r**.

Take headpin **i** and thread it through one **s**, **x**, one **s**.

Make loops at the ends of the straight pins and of the headpin using round nose pliers and join the pieces together starting from the jump ring (*see diagram below*).

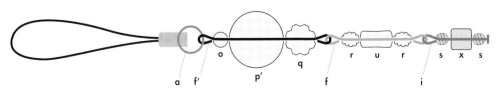

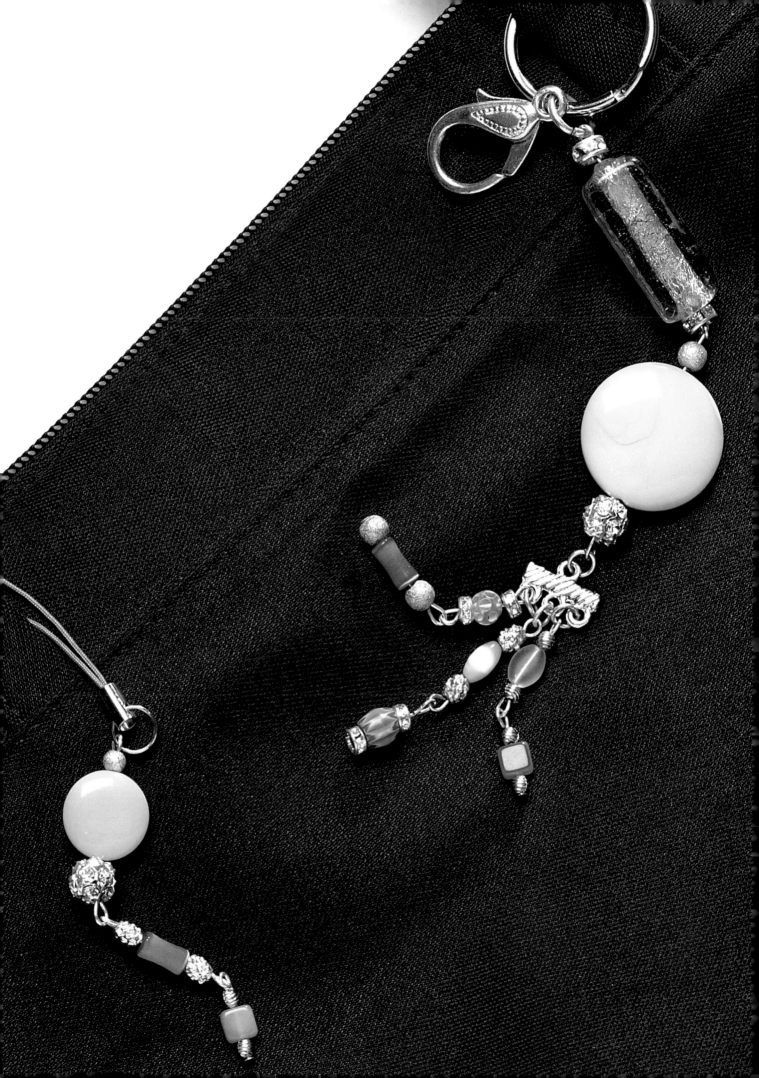

ALICE

Length: 14cm (5½in)

1 x 2.5cm split ring **a** (silver)
2 open jump rings (silver) : 1 x 0.5cm **b** and 1 x 0.8cm **c**
4 x 2cm long straight pins (silver)
12 x 5.5cm long headpins (silver)
48 x 0.5cm round beads **d** (silver)
48 x 0.3cm ridged beads **e** (silver)
28 round cat's eye beads: 6 x 0.8cm (2 dark blue **f**, 2 blue **g**, 2 turquoise **h**),
 10 x 0.6cm (3 dark blue **i**, 4 blue **J**, 3 turquoise **k**)
 and 12 x 0.4cm (6 dark blue **L**, 2 blue **m**, 4 turquoise **n**)

Attach jump ring **b** to **a**.
Take the four straight pins
and thread on to them
two **J**, one **k** and one **i**.
Make a loop at each end using
round nose pliers then join the pieces
together starting from jump ring **b**.
Attach ring **c** to the loop of the last pin.

Thread on to two headpins: one **n**, one **f**, *one **e**, one **d**, one **e**, one **d**, one **e**, one **d**, one **e**, one **d***.
On two headpins: one **L**, one **g**, then repeat from *to*.
On one headpin: one **m**, one **h**, then repeat from *to*.
On two headpins: one **n**, one **i**, then repeat from *to*.
On two headpins: one **L**, one **J**, then repeat from *to*.
On one headpin: one **m**, one **k**, then repeat from *to*.
On one headpin: one **L**, one **h**, then repeat from *to*.
On one headpin: one **L**, one **k**, then repeat from *to*.

Make a loop at the end of
each headpin and attach
them to jump ring **c**.

MATILDA

Length: 11cm (4¼in)

1 mobile phone charm strap (blue and violet)
1 x 0.5cm open jump ring **b** (silver)
3 x 2.5cm long straight pins (silver)
4 headpins: 3 x 2cm and 1 x 6cm long (silver)
8 x 0.5cm round beads **d** (silver)
20 round cat's eye beads: 4 x 0.8cm
 (1 dark blue **f**, 2 blue **g**, 1 turquoise **h**),
 4 x 0.6cm (2 dark blue **i**, 1 blue **J**,
 1 turquoise **k**) and 12 x 0.4cm
 (3 dark blue **L**, 4 blue **m**, 5 turquoise **n**)

Attach jump ring **b** to the mobile
phone charm strap.

Section n°1: take one pin and thread on one **n**, **J** and one **n**.
Make a loop at each end using round nose pliers. Take one
2cm long headpin and thread through one **n**, **k**, one **n**.
Make a loop at the end of the headpin. Join the two pieces together.

Section n°2: take a 6cm headpin and thread on to it one **m**,
one **g**, one **d**, one **m**, one **d**, one **i**, one **d**, one **m**, one **d**, one **n**.
Make a loop at the end of the headpin.

Section n°3: take one straight pin and thread on to it one **d**, **i**,
one **d**. Make a loop at each end. Take a 2cm headpin and
thread through one **L**, one **g**, one **m**. Make a loop at the end
of the headpin. Join the two pieces together.

Section n°4: take one straight pin and thread on to it one **d**, **f** and
one **d**. Make a loop at each end. Take a 2cm headpin and
thread it through one **L**, **h**, one **L**. Join the two pieces together. Attach
n°1, 2, 3 and 4 to jump ring **b**.

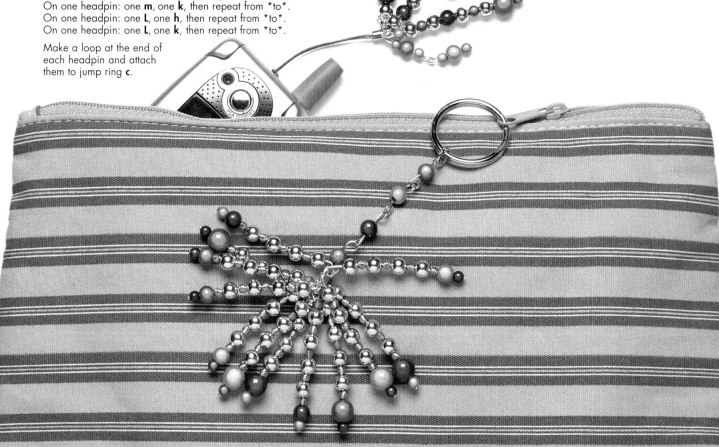

ANGELA

Length: 19cm (7½in)

1 x 5.5cm long clasp (blue)
1 x 2cm closed jump ring (silver)
5 aluminium chains: 1 x 5cm (green), 1 x 10cm (pink), 1 x 5cm (blue), 1 x 7cm (red) and 1 x 12cm long (black)
45 x 2cm long headpins (3 gold, 21 copper, 21 silver)
45 speckled beads: 13 x 1cm long star-shaped (2 green, 3 violet, 2 blue, 1 pink, 5 white), 8 x 0.7cm long heart-shaped (1 green, 3 violet, 1 pink, 3 white) and 24 x 0.7cm long flower-shaped (9 violet, 6 blue, 4 pink, 5 white)

Attach the closed jump ring to the clasp and then add the chains to the ring.

Thread the green beads on to the gold headpins, the violet and pink beads on to the copper headpins, and the blue and white beads on to the silver headpins. Make a loop at the end of each headpin using round nose pliers.

Place the green beads on to the green chain, the violet beads on to the pink chain, the blue beads on to the blue chain, the pink beads on to the red chain and the white beads on to the black chain.

ARIANNE

Length: 14cm (5½in)

1 mobile phone charm strap (pink and blue)
1 x 0.5cm open jump ring (silver)
4 x 2cm long straight pins (silver)
1 x 1.5cm long headpin (silver)
5 x 0.7cm long speckled beads: 4 heart-shaped (2 yellow **a**, 2 pink **b**) and 1 flower-shaped **c** (yellow)
4 chain links (1 green **d**, 1 pink **e**, 1 blue **f**, 1 red **g**)

Attach the open jump ring to the mobile phone charm strap.

Thread one **a**, two **b** and **c** on to the straight pins. Make a loop at each end using round nose pliers. Attach the second **a** to the headpin and make a loop at the end of the pin.

Join the pieces to the jump ring attached to the mobile phone charm strap in the following order: the **a** on the straight pin, **d**, one **b**, **e**, **c**, **f**, one **b**, **g**, one **a** on the headpin (*see diagram*).

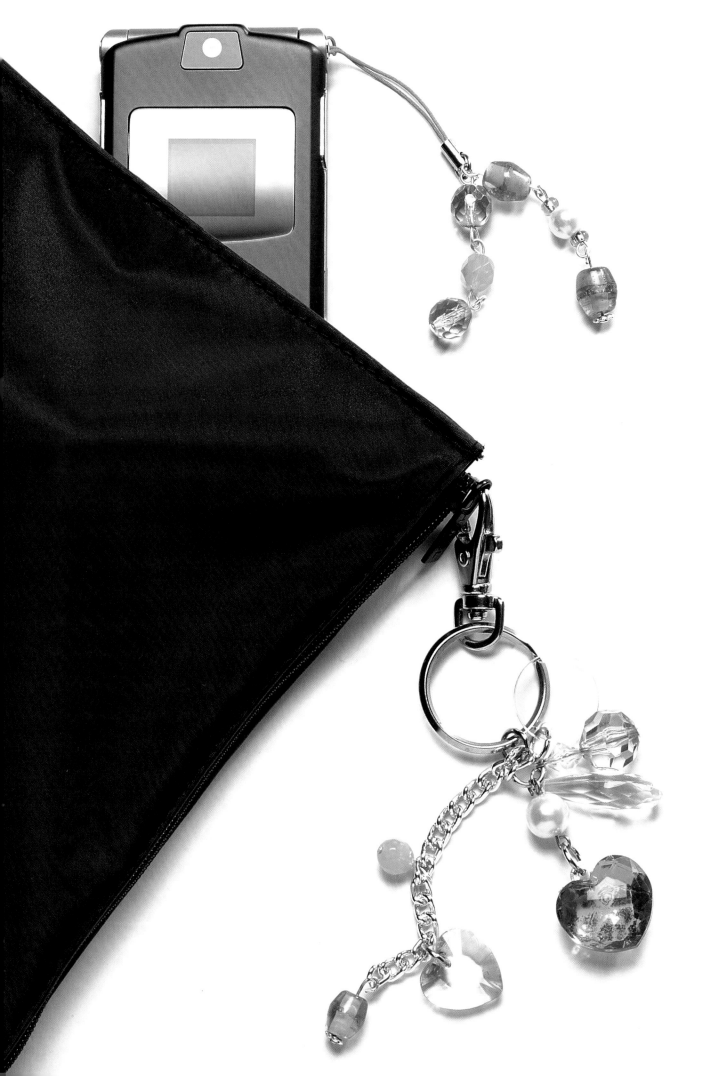

IRENE
Length: 10.5cm (4¼in)

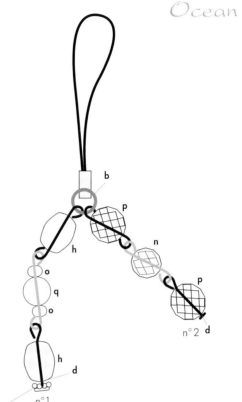

1 mobile phone charm strap (blue and green)
1 x 0.5cm open jump ring **b** (silver)
4 x 2.5cm long straight pins (silver)
2 x 2cm long headpins **d** (silver)
2 transparent cylindrical fancy beads 0.8cm diameter and 1cm long **h** (gold-edged blue)
4 round beads: 1 x 0.8cm faceted **n** (turquoise), 2 x 1cm transparent faceted **p** (blue),
 1 x 0.7cm pearlised **q** (white)
2 x 0.4cm transparent rocaille beads **o** (blue)
1 x 0.5cm diameter spacer **y** (silver)

Attach **b** to the mobile phone charm strap.
Section n°1 : thread one **h** on one straight pin; one **o**, **q**, one **o** on one straight
pin; the spacer **y** and one **h** on one headpin **d**. Make loops at the ends of
each pin using round nose pliers and join the pieces together (*see diagram*).
Section n°2 : thread one **p** on one straight pin, **n** on one straight pin, and
one **p** on headpin **d**. Make loops at the ends of each pin and join
the pieces together.
Attach these sections n°1 and 2 to jump ring **b** (*see diagram*).

ANNA
Length: 14.5cm (5¾in)

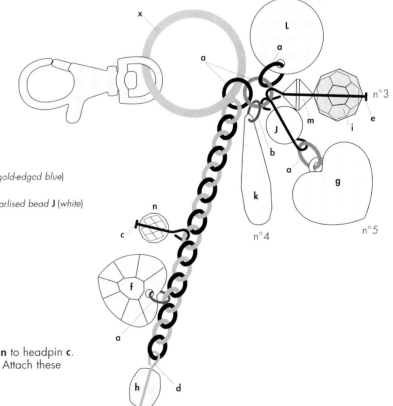

1 x 3.5cm long clasp (silver)
1 x 2.5cm double split ring **x** (silver)
6 open jump rings (silver) : 5 x 0.6cm **a** and 1 x 0.5cm **b**
1 x 7cm long chain (silver)
1 x 2cm long straight pin (silver)
3 headpins, 1.5, 2 and 2.5cm long **c**, **d**, **e** (silver)
1 x 1.5cm long transparent heart-shaped faceted fancy bead **f** (white)
1 x 2cm long heart-shaped faceted pendant **g** (blue and silver)
1 transparent cylindrical fancy bead, 0.8cm diameter and 1cm long **h** (gold-edged blue)
1 x 0.5cm diameter spacer **y** (silver)
3 round beads:1 x 1.8cm transparent faceted bead **i** (blue), 1 x 1cm pearlised bead **J** (white)
 and 1 x 0.8cm faceted bead **n** (turquoise)
1 x 3cm long transparent teardrop-shaped faceted bead **k** (white)
1 x 2cm transparent disc-shaped bead **L** (white)
1 x 0.8cm diameter transparent bicone faceted bead **m** (white)

Attach the double split ring **x** to the clasp and then attach
two **a**, linked together, to the ring.
Section n°1 : add spacer **y** and **h** to headpin **d**, one **a** to **f**, **n** to headpin **c**.
Make loops at the ends of the pins using round nose pliers. Attach these
pieces to the chain.

Section n°2 : attach **L** to one **a**.

Section n°3 : take headpin **e** and thread **i** and **m** on to it. Make a loop at the end.

Section n°4 : attach **b** to **k**.

Section n°5 : thread the straight pin through **J** and make a loop at each end of it.
Attach pendant **g** to the bottom loop using one **a**.

Attach section n°1 to the first ring **a** and n°2, 3, 4 and 5 to the second **a** (*see diagram*).

MELISSA

Length: 9 cm (3½in)

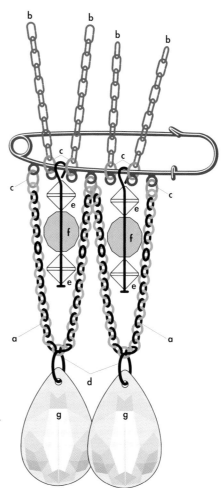

1 x 5.5cm long kilt pin with 7 loops (copper)
6 chains: 2 x 9cm **a** (matt copper) and
 4 x 3cm long **b** (copper)
2 x 3.5cm long headpins (copper)
9 open jump rings: 7 x 0.5cm **c** (copper) and
 2 x 0.8cm **d** (gold)
4 x 0.7cm diameter bicone beads **e** (white)
2 x 1cm round faceted beads **f** (brown)
2 x 3cm long transparent faceted pendants in the shape
 of teardrops **g** (yellow)

Attach chains **a** and **b** to the kilt pin using
jump rings **c** (*see diagram*).

Attach two **g** to chains **a** using jump rings **d**.
Thread one **e**, one **f** and one **e** on to each headpin.

Make a loop at the end of the headpins using
round nose pliers, then attach everything to
the kilt pin.

AMINA

Length: 12cm (4¾in)

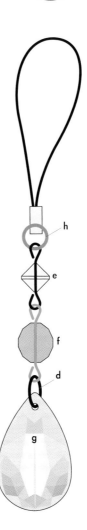

1 mobile phone charm strap (yellow)
2 open jump rings: 1 x 0.8cm **d** (gold) and 1 x 0.5cm **h** (copper)
1 x 0.7cm diameter bicone bead **e** (white)
1 x 1cm round faceted bead **f** (brown)
1 x 3cm long transparent faceted pendant in the shape
 of a teardrop **g** (yellow)
2 x 2cm long straight pins (copper)

Attach **h** to the mobile phone charm strap.
Thread **e** and **f** on to the straight pins and then
make a loop at each end using round nose pliers.
Join the two pins together and attach them to **h**.

Attach ring **d** to **g** and join this section to the loop
of the last straight pin (*see diagram*).

ELIZABETH

Length: 9 cm (3½in)

1 x 2.5cm split ring **a** (silver)
2 open jump rings (silver) : 1 x 0.7cm **b** and 1 x 0.4cm **c**
4 x 1cm diameter spacers **x** (silver)
1 straight pin and 1 headpin, each 3.5cm long (silver)
2 fancy beads, 3cm and 4cm diameter **d** and **e** (orange)

Attach **b** to **a**.
Thread **d** on to the
straight pin with one
spacer **x** on each side.
Make a loop at each end
using round nose pliers.
Attach the section to **b**.
Attach **c** to the bottom of
the straight pin (*see diagram*).

Thread **e** on to the headpin
with one spacer on each side.
Make a loop at the end of
the headpin.
Attach the section to **c**.

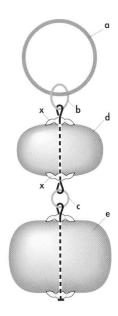

JASMINE

Length: 7cm (2¾in)

1 mobile phone charm strap (white)
1 x 0.7cm closed jump ring **f** (silver)
2 x 1cm diameter spacers **x** (silver)
1 x 2cm diameter fancy bead **g** (orange)
1 x 2.5cm long headpin (silver)

Attach **f** to the mobile phone charm strap.

Take the headpin and thread **g**
on to it with one spacer **x** on each side.
Make a loop at the end of the headpin
using round nose pliers.
Attach this section to **f**.

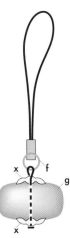

Tip
Very big beads sometimes have
large holes. Make sure you choose the
diameter of your spacers to suit them.

SOPHIE

Length: 16cm (6¼in)

1 x 2.5cm split ring **a** (gold)
2 open jump rings (gold): 1 x 0.6cm **b** and 1 x 1.2cm **c** (gold)
2 x 4.5cm long straight pins (gold)
1 olive-shaped bead, 3cm long and 1cm diameter **d** (amber)
1 x 1.5cm wide lozenge-shaped bead **e** (brown)
1 x 5.5cm diameter large round charm **f** (amber)

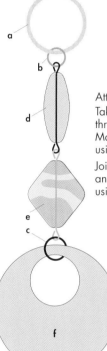

Attach **b** to **a**.
Take the two pins and
thread through **d** and **e**.
Make a loop at each end
using round nose pliers.

Join these pieces together
and attach to **b**, with **f** added
using ring **c** (*see diagram*).

CARMEL

Length: 12cm (4¾in)

1 mobile phone charm strap (brown)
1 x 0.5cm open jump ring **g** (gold)
2 straight pins (gold): 1 x 2.5cm **h**
and 1 x 3.5cm long **i** (gold)
1 x 2.5cm long headpin (gold)
2 x 1cm round beads **J** (amber)
1 olive-shaped bead, 2.5cm long and 1cm
diameter **k** (amber)
1 x 0.3cm diameter ridged oval bead **L** (gold)

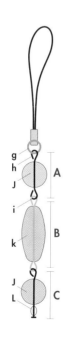

Attach **g** to the mobile phone charm strap.

Take straight pin **h** and thread one **J** on
to it. Make a loop at each end using
round nose pliers (**A**).
Take straight pin **i** and thread **k** on to it.
Make a loop at each end (**B**).

Take the headpin and thread **L** and one **J** on to it.
Make a loop (**C**).

Join **A**, **B** and **C** (*see diagram*).

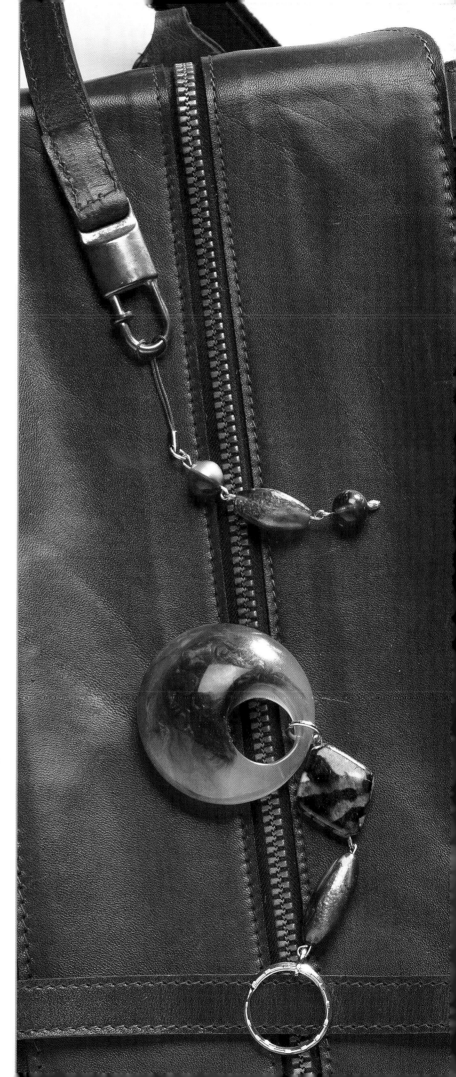

ADELE

Length: 12cm (4¾in)

1 x 2.5cm split ring **a** (gold)
2 open jump rings (gold): 1 x 0.5cm **b** and 1 x 0.7cm **c**
1 connector with 5 loops (gold)
1 x 3cm long teardrop-shaped charm **d** (brown and gold)
2 x 1cm long headpins (gold)
1 x 2.5cm long straight pin (gold)
2 x 0.5cm round beads **e** (copper)
20 flat beads: 1 x 0.8cm **f** (brown and beige)
 and 19 x 0.6cm diameter **g** (copper and beige)
22 x 0.3cm diameter ridged beads **h** (gold)
2 crimp beads (gold)
1 x 18cm length of nylon cord

Attach **c** to **a**.
Take the straight pin, thread through one **h**, **f**, one **h**
and make a loop at each end using round nose pliers (**A**).
Attach **A** to **c**.
Attach the connector to **A**.
Thread the twenty **h** and nineteen **g** alternately on to the
nylon cord (*see diagram*).
Insert one crimp bead at each end of the cord.
Thread the ends of the cord into the side loops
of the connector and back into the crimp beads.
Flatten these beads using flat nose pliers.
Thread one **e** on to each headpin and make
loops at the ends.
Attach these two sections to the connector (*see diagram*).
Attach **d** to the central loop of the connector using **b**.

OPHELIA

Length: 10cm (4in)

1 mobile phone charm strap (brown)
1 x 0.5cm open jump ring **b** (gold)
1 x 2.5cm long straight pin (gold)
1 x 1.5cm long headpin (gold)
1 connector with 3 loops (gold)
9 round beads: 8 x 0.5cm **e** (copper) and 1 x 0.8cm **i** (copper and beige)
1 x 0.6cm diameter flat bead **g** (copper and beige)
9 x 0.3cm diameter ridged beads **h** (gold)
1 x 9cm length of nylon cord
2 crimp beads (gold)

Attach **b** to the mobile phone charm strap.
Take the straight pin, thread one **h**, **g**, one **h** on to it and make a loop at each
end using round nose pliers (**B**). Fasten **B** on to **b**.
Attach the connector to **B**.
Thread seven **h** and eight **e** alternately on to the nylon cord (*see diagram*).
Insert one crimp bead at each end of the cord.
Thread the ends of the cord through the side loops of the connector and back
through each crimp bead. Flatten these beads using flat nose pliers.
Take the headpin, thread it through **i** and make a loop at the end (**C**).
Attach **C** to the central loop of the connector.

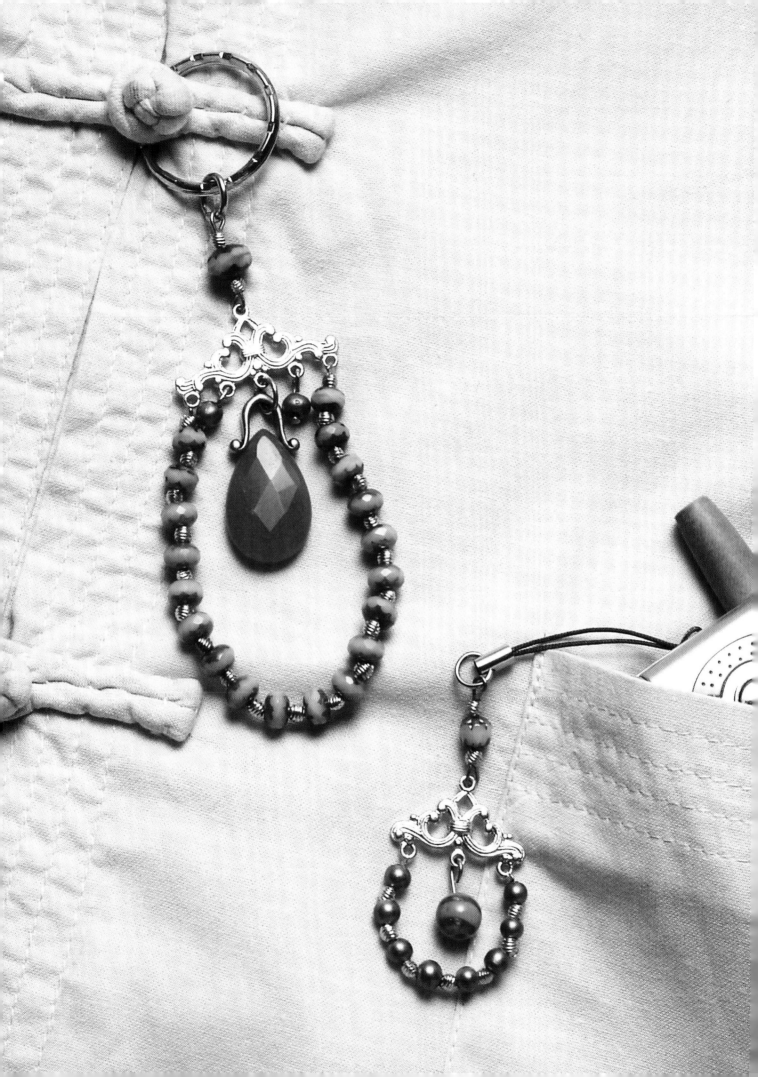

VANILLA

Length: 17cm (6¾in)

1 x 2.5cm split ring **a** (silver)
37 open jump rings (silver) : 1 x 0.7cm **b** and 36 x 0.3cm **c**
1 x 1.5cm long straight pin **x** (silver)
1 end cap **y** (silver)
2 x 16cm lengths of nylon cord
24 x 1.5cm pearlised sequins (6 dark green **d**, 7 pink **e**, 4 pale pink **f**, 5 pale green **g**, 2 white **h**)
2 x 1cm long transparent fish-shaped charms (pale blue **i**, turquoise **J**)
28 pebble-shaped fancy beads: 7 approx. 1.5cm long (2 pink **k**, 2 turquoise **L**, 2 blue **m**, 1 salmon pink **n**)
 and 21 approx. 0.5cm long (3 orange **o**, 10 white **p**, 5 pink **q**, 3 green **r**)

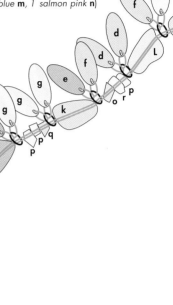

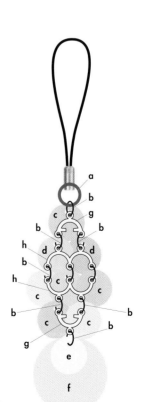

Attach **b** to **a**.

Section n°1 : thread the loop of **i** on to
the middle of the nylon cord.

Fold the cord in half and thread the following
beads on to the two strands:
one **q**, one **p**, one **o**, one **n**, two **p**, one **q**,
one **k**, one **o**, one **r**, one **p**, one **L**, one **m**.

Add sequins **d**, **e**, **f**, **g**, **h**, assembling them
in pairs using eighteen of the **c** (*see diagram*).

Knot the strands of nylon cord together.
Slide one end of straight pin **x** into this knot
and make a loop using round nose pliers.

Insert the other end of the straight pin into end cap **y**.
Make a loop on it, then pull to hide the knot.

Proceed in the same way for n°2 by threading **J**
and then the following beads:
one **o**, one **p**, one **q**, one **k**, one **q**, two **p**, one **L**, two **r**,
one **p**, one **m**, one **q**, two **p** and the sequins (*see diagram*).

Attach end cap **y** to **b** by means of the top loop of straight pin **x**.

n° 1

EMILY

Length: 12cm (4¾in)

1 mobile phone charm strap (blue)
10 open jump rings (silver) : 1 x 0.5cm **a** and 9 x 0.3cm **b**
10 pearlised sequins: 8 x 1.2cm (6 green **c**, 2 white **d**), 1 x 1.5cm **e** (green)
 and 1 x 2.5cm **f** (green)
4 connectors (silver) : 2 with 2 loops **g** and 2 with 3 loops **h**

Attach **a** to the mobile phone charm strap, then one **b** to **a** and
one **g** on to the same **b**.

Continue by attaching two **h** and one **g** together using other
jump rings **b**.

Next, attach each **c** and **d** to a **b** (*see diagram*).
End by attaching both **e** and **f** to the last connector by means of a **b**.

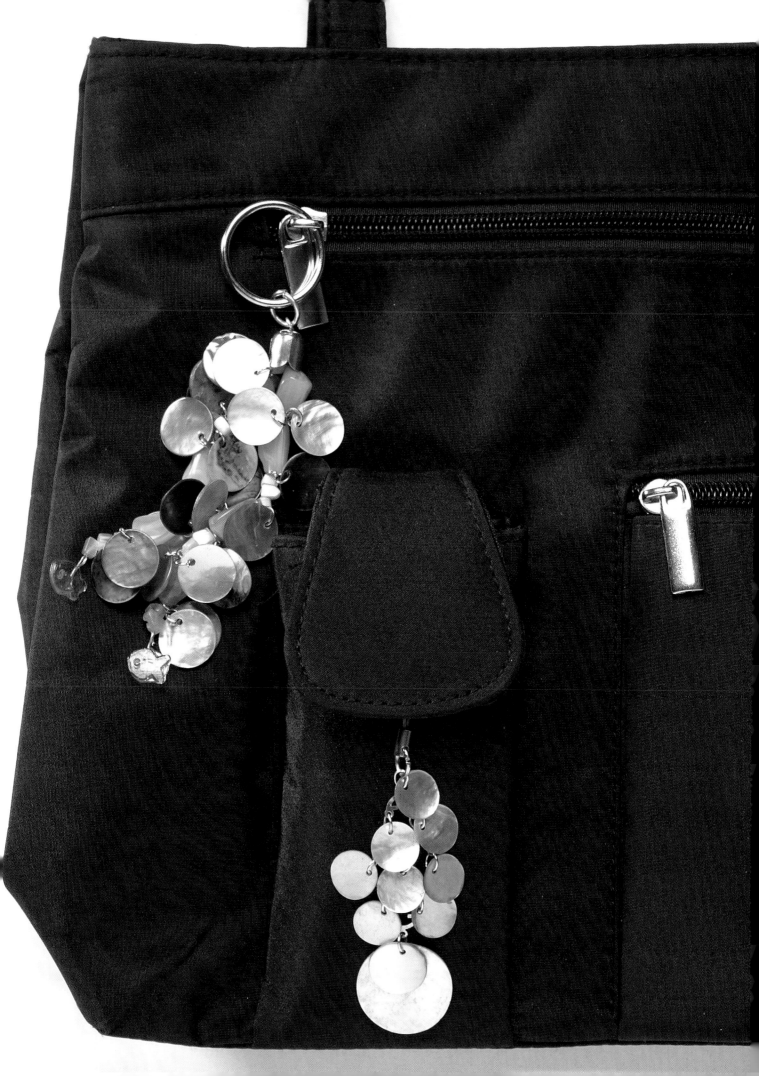

ADRIANNE

Length: 15.5cm (6¼in)

1 x 3.5cm long clasp (gold)
1 x 2.5cm split ring **a** (gold)
10 open jump rings (gold) :
 3 x 0.6cm **b** and 7 x 0.5cm **c**
5 round mother-of-pearl sequins:
 4 x 1.5cm (2 white **d**, 2 dark green **e**)
 and 1 x 3cm **f** (white)
1 x 4cm long mother-of-pearl sequin in the
 shape of a teardrop **g** (green)
1 x 2.5cm long mother-of-pearl sequin
 in the shape of a heart **h** (orange)
2 x 5cm long chains (gold) :
 1 with round links **i**
 1 with fine oval links **J**
1 x 3cm long chain with thick
 oval links **k** (gold)

Attach **a** to the clasp and then three **b** on to **a**.
Take chain **k** and attach one **e** and **f** to it by means of two **c**.
Take chain **J** and attach one **d** and **h** to it by means of two **c**.
Take chain **i** and attach **g**, one **e** and one **d** to it by means of three **c** (*see diagram*).
Attach these three sections to the three **b**.

CLAIRE

Length: 9.5cm (3¾in)

1 mobile phone charm strap (fluorescent yellow and orange)
2 x 0.5cm open jump rings **c** (gold)
2 round mother-of-pearl sequins: 1 x 1.5cm (green)
and 1 x 3.5cm (white)

Join the two jump rings **c**
together, thread the first on
to the mobile phone charm
strap and the second on
to the two sequins
(*see diagram*).

Tip
Mother-of-pearl sequins are fragile.
Attach them with care so as not
to break them at the hole.

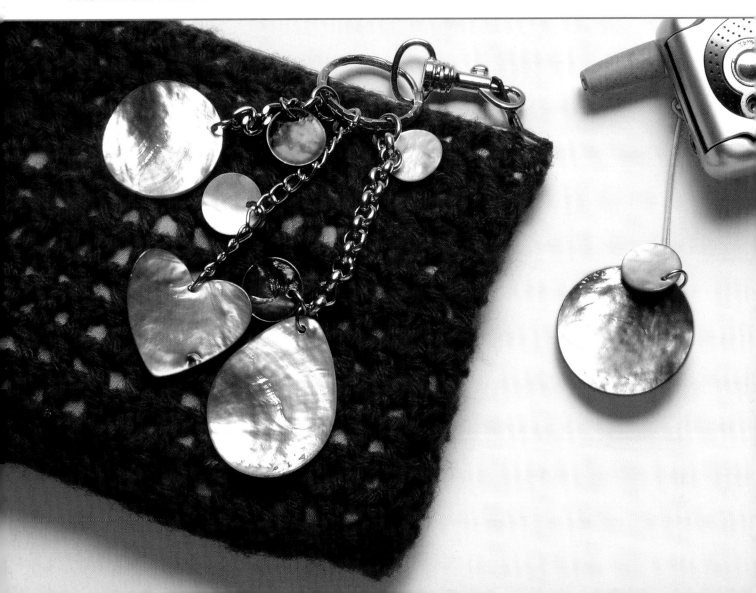

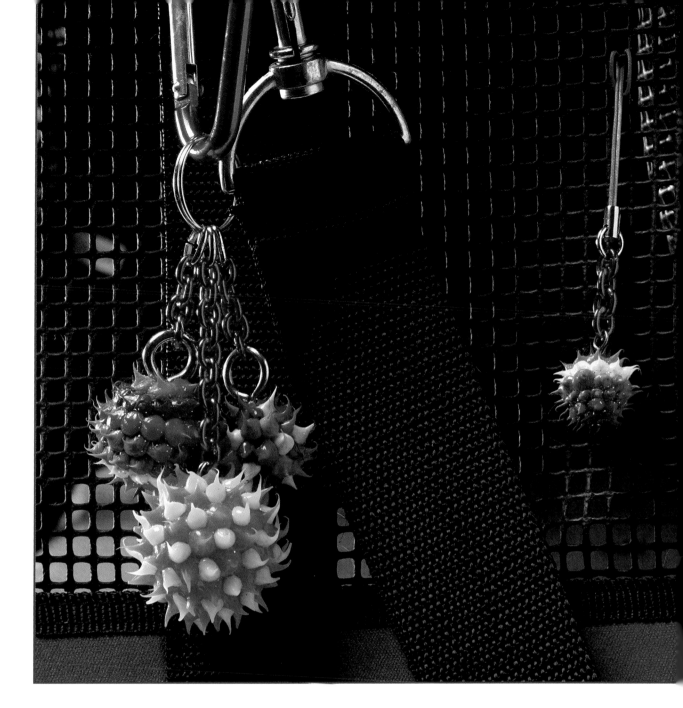

Alana

Length: 15cm (6in)

1 x 5.5cm long clasp (magenta)
1 x 2cm closed jump ring (silver)
3 x 0.7cm open jump rings (silver)
3 aluminium chains, 2, 2.5
 and 4.5cm long (magenta)
3 spiky ball charms (multicoloured)

Fix the closed jump ring on to the clasp.

Attach one open jump ring and one charm
to the end of each chain (*see diagram*).

Fasten the three sections on to the closed jump ring.

Claudia

Length: 9 cm (3½in)

1 mobile phone charm strap
 (multicoloured)
1 x 0.5cm open jump ring **a** (silver)
1 x 2cm long aluminium chain
 b (magenta)
1 spiky ball charm **c** (multicoloured)

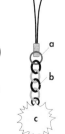

Attach **a** to the mobile phone charm strap, then **b**
to **a** and **c** to **b** (*see diagram*).

Melanie

Length: 16cm (6¼in)

1 x 5cm long clasp (green)
1 x 2cm closed jump ring **x** (silver)
3 x 0.3cm open jump rings **y** (silver)
1 fabric tassel (red)
2 aluminium chains, 4cm and 8cm long (red)
4 headpins: 3 x 3cm, 1 x 3.5cm long (silver)
6 'Christmas' charms **a**
1 x 2.5cm diameter sequined ball (green)
12 x 0.5cm diameter flower-shaped beads **b** (silver)
8 x 0.8cm diameter fancy beads **c** (red)
2 x 0.7cm diameter spacers (silver)
2 crimp beads **z** (silver)
1 x 9cm length of nylon cord

n°4

x

y

z

a

n°1

b

c

a

b

c

a

b

b c b

c

a

b

b c b

a

b

c

a

b c b

b

c

z

a

b

y

n°3

n°2

Fix closed jump ring **x** on to the clasp.

Section n°1 : take the small chain and attach one **a**.

Section n°2 : thread one **b**, one **c**, one **b**, one **a**, one **c**, one **b**, one **a**, one **c**, one **b**, one **a**, one **c**, one **b**, one **a**, one **c**, one **b** on to the nylon cord. Slip one crimp bead **z** on to each end of the cord. Pass each end of the cord through one open jump ring **y** then back into the same crimp bead **z**. Flatten these beads **z** using flat nose pliers.

Thread the sequined ball and the spacers on to the 3.5cm headpin. Make a loop at the end of it using round nose pliers and then attach this section to the open jump ring previously assembled.

Section n°3 : thread one **b**, one **c**, one **b** on to the three 3cm headpins then form a loop at the ends using round nose pliers. Take the large chain and attach the three headpins and one **a** to it *(see diagram)*.

Section n°4 : attach one open jump ring on to the tassel.

Fasten these four sections to the closed jump ring attached to the clasp *(see diagram)*.

Josephine

Length: 12cm (4¾in)

y

b

c

b

b

c

b

1 mobile phone charm strap (red and white)
1 x 0.5cm open jump ring **y** (silver)
1 x 2.5cm diameter sequined ball (green)
2 x 0.7cm diameter spacers (silver)
1 x 3.5cm long headpin (silver)
2 x 3cm long straight pins (silver)
4 x 0.5cm diameter flower-shaped beads **b** (silver)
2 x 0.8cm diameter fancy beads **c** (red)

Fix jump ring **y** on to the mobile phone charm strap. Thread one **b**, one **c** and one **b** on to each of the straight pins and then make a loop at each end using round nose pliers.

Join these pieces together and then attach to ring **y** of the mobile phone charm strap.

Thread the sequined ball and the spacers on to the 3.5cm headpin. Make a loop at the end of it and attach the entire section to the loop of the last pin *(see diagram)*.

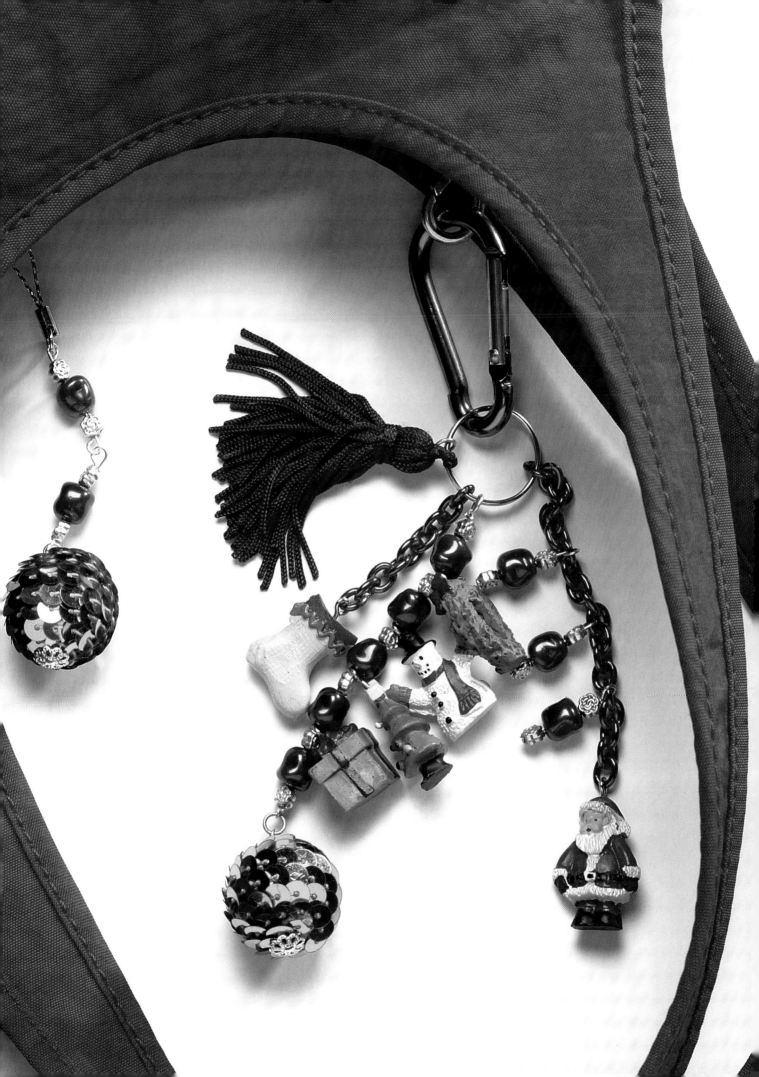

IRINA

Length: 11cm (4¼in)

1 x 2.5cm split ring (gold)
2 open jump rings, 0.6cm **a** and 1cm **b** (gold)
1 x 3cm long chain (gold)
5 x 1.5cm long headpins (gold)
8 x 2cm long straight pins (gold)
13 x 0.4cm round beads (gold)
1 transparent charm in the shape of a boot
 (white and gold)

Attach **a** to the double split ring,
then fix the chain to the jump ring.

Thread one bead on to each of the five
headpins and on to each of the eight straight
pins. Make a loop at the ends of the headpins
and of the straight pins using round nose
pliers. Attach these sections to the chain
(see diagram).

Fasten **b** to the end of the chain
and then the charm to the jump ring.

Tip

Make the most of the Christmas period
by using Christmas tree charms.

MARTINA

Length: 11cm (4¼in)

1 mobile phone charm strap (yellow)
1 x 0.5cm open jump ring (gold)
1 x 2.5cm long chain (gold)
5 x 1.5cm long headpins (gold)
10 x 2cm long straight pins (gold)
15 x 0.4cm round beads (gold)

Attach the jump ring to the mobile phone
charm strap and then the chain to the rin·

Section n°1: thread one bead each on t·
two of the straight pins and on to one
headpin. Make loops at the ends using
round nose pliers and then join these piec·
together. Repeat this process four times.

Fix each of these five segments to a
link of the chain *(see diagram)*.

a

b

n°1

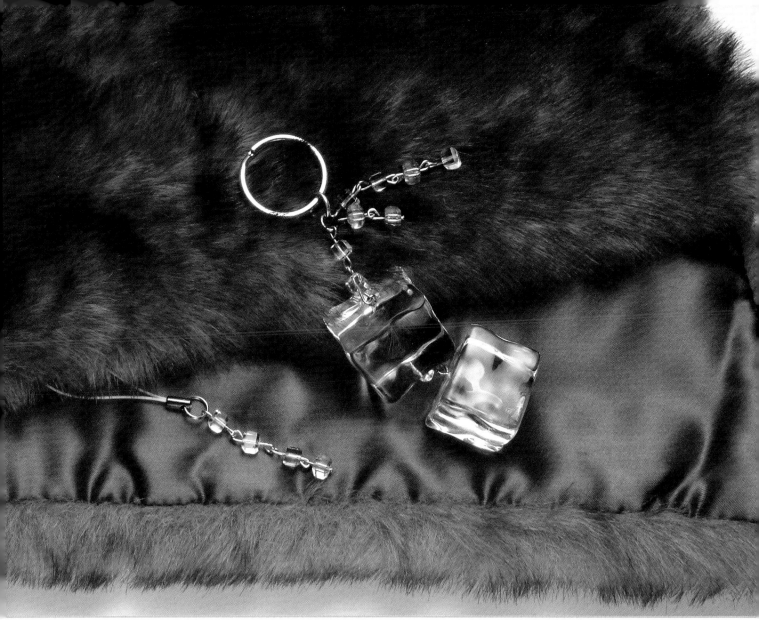

DIANA

Length: 10cm (4in)

1 mobile phone charm strap (white)
1 x 0.7cm open jump ring **c** (silver)
3 x 2cm long straight pins (silver)
1 x 1.5cm long headpin (silver)
4 transparent faceted cubic beads measuring
 0.5cm on each side **f** (silver)

Attach **c** to the mobile phone charm strap. Take the straight pins and the headpin and thread one **f** on to each of them. Make loops at the ends of the straight pins and headpin using round nose pliers. Join these pieces together and attach to **c** *(see diagram)*.

AMELIA

Length: 13cm (5in)

1 x 2.5cm split ring **a** (silver)
2 open jump rings (silver) :1 x 0.5cm **b**
 and 1 x 0.7cm **c**
7 x 2cm long straight pins (silver)
2 x 1.5cm long headpins (silver)
2 'ice-cube' pendants, **d** and **e**, measuring 2.5cm
 on each side, 1 with 2 loops
9 transparent faceted cubic beads measuring 0.5cm
 on each side **f** (white)

Attach **c** to **a**, then **b** to **c**.

Thread one **f** on to each of the seven straight pins and the two headpins. Make loops at the ends of them using round nose pliers. Join these pieces together, adding pendants **d** and **e** *(see diagram)*.

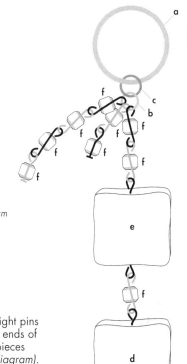

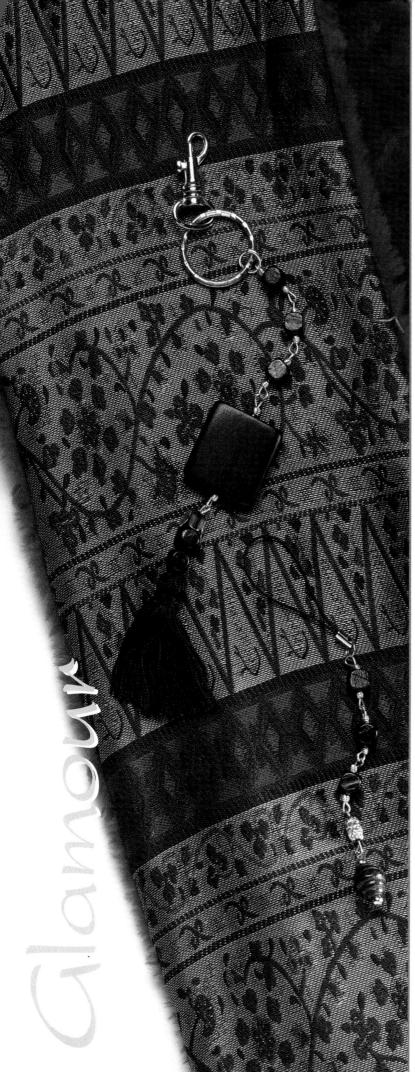

AGATHA

Length: 24cm (9½in)

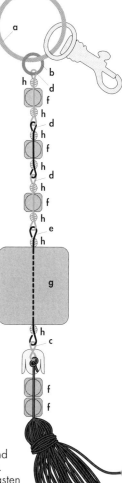

1 x 3.5cm long clasp (gold)
1 x 2.5cm split ring **a** (gold)
1 x 0.6cm open jump ring **b** (gold)
5 straight pins: 1 x 1.5cm **c**, 3 x 2.5cm **d**
 and 1 x 5cm **e** long (gold)
5 wooden cubic beads measuring
 0.5cm on each side **f** (black)
1 wooden square bead measuring
 3cm on each side **g** (black)
8 x 0.3cm diameter ridged beads **h** (gold)
1 end cap (gold)
1 fabric tassel (black)

Attach jump ring **a** to the clasp,
then **b** to **a**.

Take one **d** and thread on one **h**,
one **f**, one **h**. Make a loop at each
end using round nose pliers.
Repeat this process twice. Join
the pieces together (see diagram).

Take **e** and thread one **h**, **g**, one **h** on
to it. Make a loop at each end and
join this section on to the previous
pin (see diagram).

Take the tassel and thread its
attachment through two **f**.
Make two knots and push **c**
through the middle of them. Add the end
cap and make a loop at each end of **c**.
Attach this section to the last pin and fasten
everything on to **b** (see diagram).

CAMILLA

Length: 14cm (5½in)

1 mobile phone charm strap (black)
1 x 0.6cm closed jump ring (gold)
4 x 2.5cm long straight pins (gold)
1 x 2.5cm long headpin (gold)
3 wooden cubic beads measuring 0.5cm on each side **f** (black)
6 x 0.3cm diameter ridged beads **h** (gold)
2 x 0.4cm round beads **i** (gold)
1 x 0.8cm long nugget-shaped bead **J** (gold)
1 x 1.3cm diameter wooden olive-shaped ridged bead **k** (bla

Attach the jump ring to the mobile phone
charm strap. Take one straight pin and thread
one **h**, one **f** and one **h** on to it. Make a loop
at each end of the pin using round nose
pliers. Repeat this process twice.

Take the last pin and thread **J** on to it.
Make a loop at each end.

Finally thread one **i**, **k** and one **i** on to the
headpin and make a loop at one end.

Join the pieces together and attach to
ring (see diagram).

BARBARA

Length: 16cm (6¼in)

1 x 2.5cm split ring **a** (silver)
1 x 0.5cm open jump ring **b** (silver)
1 x 2.5cm long chain (silver)
4 straight pins: 2 x 2.5cm **c**, 1 x 3cm **d**,
 1 x 3.5cm **e** (silver)
2 silk pom-poms, 1.5cm and 2cm diameter
 f and **g** (black)
4 x 0.7cm diameter spacers **h** (silver)
2 x 0.7cm lead glass balls **i** (silver)
1 mink pom-pom **J** (black)

Attach **b** to **a** then the chain to **b**.
Take pin **d** and thread it through one **h**, **f**, one **h**.
Make a loop at each end of the pin using round nose
pliers and attach this section to the chain.

Take one pin **c** and thread it through one **i** (**A**).
Make loops and attach this section to the previous pin.

Take one pin **e** and thread it through one **h**, **g**, one **h**.
Make loops and attach this section to **A**.

Make another section **A** and attach to the previous pin.

Finally, attach pom-pom **J** to the previous section **A** *(see diagram)*.

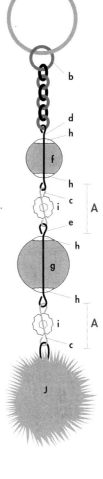

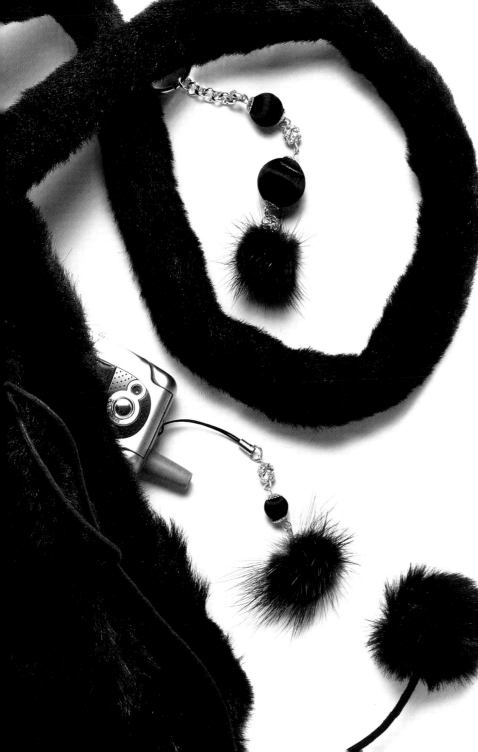

ESTELLE

Length: 13cm (5in)

1 mobile phone charm strap (black)
1 x 0.5cm open jump ring **b** (silver)
3 x 2.5cm long straight pins **c** (silver)
2 x 0.7cm diameter spacers **h** (silver)
2 x 0.7cm diameter lead glass balls
 i (silver)
1 mink pom-pom **J** (black)
1 x 1cm diameter silk pom-pom
 k (black)

Attach **b** to the mobile phone charm strap.
Make section **A** *(see* BARBARA *above)*
and then attach it to **b**.
Take one pin **c** and thread it through one **h**, **k**, one **h**.
Make a loop at each end using round nose
pliers and attach this section to **A**.

Make another section **A** and attach to the
previous pin. Finally, attach pom-pom **J**
to the previous section **A** *(see diagram)*.

Note
Silk pom-poms are available from bead shops and
haberdashers.

Margaret

Length: 15cm (6in)

*1 x 2.5cm split ring **a** (silver)*
*3 x 0.5cm open jump rings **b** (silver)*
*2 chains, 1.5 and 6.5cm long **c** and **d** (silver)*
*4 straight pins: 2 x 1.5cm **e**, 1 x 3cm **f**, 1 x 3.5cm **g** long (silver)*
*3 headpins, 1.5cm, 2.5cm and 3cm long **h**, **i**, **j** (silver)*
*7 round cat's eye beads (green) : 5 x 0.4cm **k** and 2 x 0.8cm **L***
*2 transparent square faceted beads measuring 1.5cm on each side **m** (green)*
*1 transparent cubic bead measuring 0.3cm on each side **n** (green)*
1 chain tassel (silver)
2 x 0.8cm diameter spacers (silver)
*1 x 2.5cm diameter round fancy bead **o** (green)*

Attach three **b** to **a**.
Attach chain **c** to the first jump ring **b**.
Take headpin **h** and attach one **L**. Make a loop at the
end of **h** using round nose pliers and attach it to **c**.
Thread one **k**, one **L**, one **k** on to headpin **i**, make a
loop at the end of **i** and attach this section to **c**.

Attach chain **d** to the second jump ring **b**.
Take headpin **J**, thread one **k**, one **m**, one **k** on to it,
make a loop at the end of **J** and attach this section to **d**.

Take two pins **e** and thread through one **k** and **n**.
Thread one **m** on to pin **f** and then **o** on to pin **g** with two
spacers on either side. Make a loop at each end of the
pins, join them together and attach to the third jump ring **b**.
Attach the tassel to this last section *(see diagram)*.

Note

Chain tassels are available commercially, but you can make
them yourself using fine chains and an end cap.

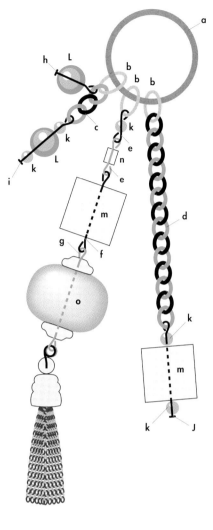

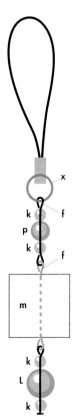

Louise

Length: 12cm (4¾in)

1 mobile phone charm strap (green)
*1 x 0.7cm closed jump ring **x** (silver)*
*2 x 3cm long straight pins **f** (silver)*
*1 x 2.5cm long headpin **i** (silver)*
*6 round cat's eye beads (green) : 4 x 0.4cm **k**, 1 x 0.8cm **L** and 1 x 0.6cm **p***
*1 transparent square faceted bead measuring 1.5cm on each side **m** (green)*

Attach jump ring **x** to the mobile phone charm strap.
Take one straight pin **f** and thread one **k**, **p**, one **k** on it.
Make a loop at each end of this pin using round nose pliers.

Slip **m** on to the second pin **f** and then make a loop at each end.

Thread one **k**, **L**, one **k** on to headpin **i** and make a loop at its end.

Assemble these sections starting from jump ring **x**, referring to the diagram.

MADELINE

Length: 53cm (20¾in)

2 x 2.2cm split rings **a** (silver)
2 x 0.7cm open jump rings **a'** (silver)
4 cotton threads, 80cm long and 0.1cm diameter (2 red, 2 green)
wooden beads:
 13 olive-shaped beads: 8 ridged beads, 1.3cm long and 0.8cm diameter
 (2 yellow **b**, 3 green **c**, 3 magenta **d**); 5 x 2.2cm long and 0.7cm diameter (2 green **e**, 3 yellow **f**)
 8 cylindrical beads: 3 x 1cm long and 0.6cm diameter **g** (magenta); 3 x 1.7cm long
 and 0.6cm diameter **h** (red); 2 x 1.4cm long ridged beads **i** (red)
 7 round beads: 4 x 1.2cm (1 yellow **J**, 1 red **k**, 2 orange **L**),
 1 x 1.5cm ridged **m** (yellow), 1 x 1.3cm **n** (yellow), 1 x 0.8cm **o** (yellow)
 33 rectangular beads, 1.8cm long and 0.5cm wide (2 magenta **p**, 1 orange **q**)
 8 cubic beads: 5 x 1cm on each side (4 green **r**, 1 red **s**) and
 3 x 1.3cm on each side (1 orange **t**, 1 yellow **u**, 1 red **v**)
 3 teardrop-shaped beads, 1.7cm long and 1cm diameter (2 red **w**, 1 magenta **x**)

Take one red thread and one green thread and knot them together at one end **y**.

Thread one bead on to a single thread. Knot the two threads together again then thread one bead on to the other thread. Continue in this way by threading the following beads *(see diagram)*:
one **b**, one **g**, one **j**, one **c**, one **p**, one **h**, one **d**, one **r**, **m**, one **g**, **q**, one **e**, **t**, one **f**, **k**, one **w**, one **f**, **x**, one **L** and one **c**. End with a knot **y'**.

Take the other two red and green threads and proceed in the same way with a knot **z** and by threading the following beads:
one **f**, one **w**, one **r**, one **d**, one **o**, one **L**, **v**, one **b**, one **p**, one **e**, **s**, one **d**, one **r**, **n**, one **h**, **u**, one **g**, one **i**, one **c**, one **i**, one **r** and one **h**. End with a knot **z'**.
Knot together the two sections created in this way at around 10cm (4in) from each end. Attach one **a** and one **a'** at each joint.

CARLY

Length: 16.5cm (6½in)

1 mobile phone charm strap (fluorescent yellow)
1 x 0.5cm open jump ring **x** (silver)
1 cotton thread, 30cm long (green)
4 wooden beads:
1 olive-shaped ridged bead, 1.3cm long and
0.8cm diameter (yellow **b**);
1 x 1.2cm round bead (orange **L**);
1 cubic bead measuring 1cm on each side (magenta **y**);
1 teardrop-shaped bead, 1.7cm long
and 1cm diameter (green **z**)

Attach jump ring **x** to the mobile phone charm strap. Make a knot on jump ring **x** using the green thread folded in half *(see diagram)*.
Thread the beads in the same way as for MADELINE *(see above)* and in the following order: **y**, **L**, **b**, **z**. End by knotting the two strands together.

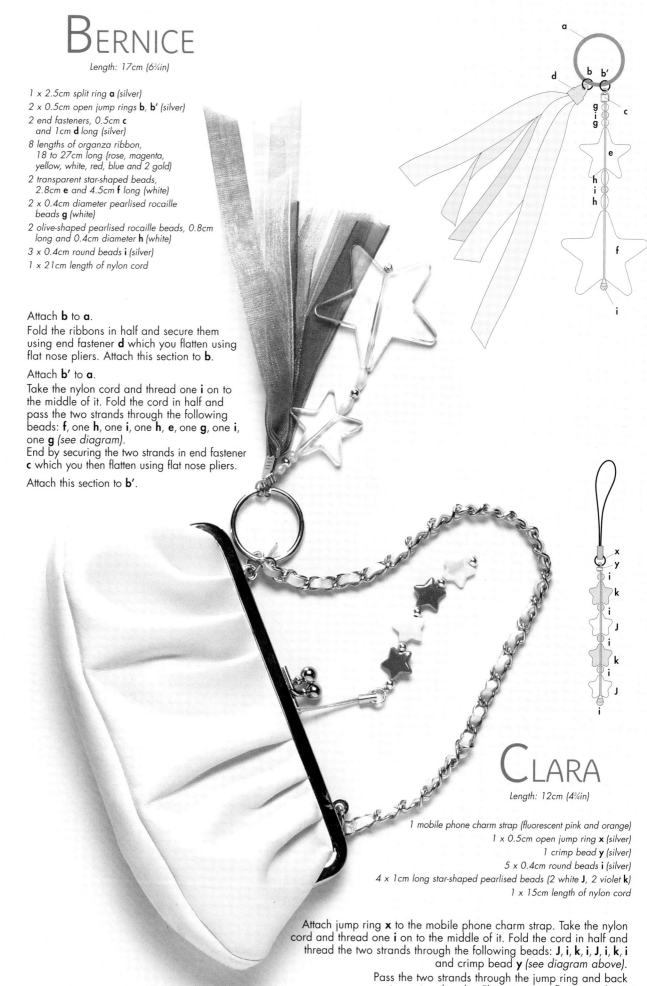

BERNICE

Length: 17cm (6¾in)

1 x 2.5cm split ring **a** (silver)
2 x 0.5cm open jump rings **b**, **b'** (silver)
2 end fasteners, 0.5cm **c**
 and 1cm **d** long (silver)
8 lengths of organza ribbon,
 18 to 27cm long (rose, magenta,
 yellow, white, red, blue and 2 gold)
2 transparent star-shaped beads,
 2.8cm **e** and 4.5cm **f** long (white)
2 x 0.4cm diameter pearlised rocaille
 beads **g** (white)
2 olive-shaped pearlised rocaille beads, 0.8cm
 long and 0.4cm diameter **h** (white)
3 x 0.4cm round beads **i** (silver)
1 x 21cm length of nylon cord

Attach **b** to **a**.
Fold the ribbons in half and secure them
using end fastener **d** which you flatten using
flat nose pliers. Attach this section to **b**.

Attach **b'** to **a**.
Take the nylon cord and thread one **i** on to
the middle of it. Fold the cord in half and
pass the two strands through the following
beads: **f**, one **h**, one **i**, one **h**, **e**, one **g**, one **i**,
one **g** (see diagram).
End by securing the two strands in end fastener
c which you then flatten using flat nose pliers.

Attach this section to **b'**.

CLARA

Length: 12cm (4¾in)

1 mobile phone charm strap (fluorescent pink and orange)
1 x 0.5cm open jump ring **x** (silver)
1 crimp bead **y** (silver)
5 x 0.4cm round beads **i** (silver)
4 x 1cm long star-shaped pearlised beads (2 white **J**, 2 violet **k**)
1 x 15cm length of nylon cord

Attach jump ring **x** to the mobile phone charm strap. Take the nylon
cord and thread one **i** on to the middle of it. Fold the cord in half and
thread the two strands through the following beads: **J**, **i**, **k**, **i**, **J**, **i**, **k**, **i**
and crimp bead **y** (see diagram above).
Pass the two strands through the jump ring and back
into crimp bead **y**. Flatten it using flat nose pliers.

Ribbon Trim

EDWINA

Length: 19cm (7½in)

1 x 5.5cm long clasp (silver)

1 x 2.5cm split ring **a** (silver)

10 open jump rings (silver): 3 x 0.7cm **b** and 7 x 0.5cm **c**

3 chains, 3cm, 5cm and 6.5cm long **d**, **e**, **f** (silver)

3 x 1.5cm long headpins (silver)

1 x 1.2cm diameter round bell (silver)

1 x 0.7cm diameter numbered round fancy bead **g** (black and white)

1 dice-shaped cubic bead measuring 0.7cm on each side **h** (black)

1 transparent fancy bead in the shape of a cat's head **i** (blue)

1 fancy bead in the shape of a ladybird **J** (red and black)

2 medallion-shaped pendants **k** (silver)

1 transparent fish-shaped pendant **L** (blue and white)

1 pendant in the shape of a monkey's head **m**

1 pendant in the shape of a banana **n** (yellow)

1 pendant in the shape of the Eiffel Tower **o** (yellow)

1 transparent heart-shaped pendant **p** (pink)

6 ribbons, 0.3cm wide and 20cm long
 (orange, violet, pink, blue, yellow, green)

1 end fastener **x** (silver)

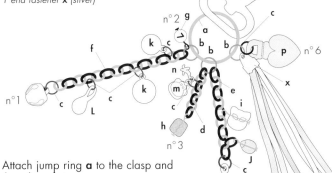

Attach jump ring **a** to the clasp and then three **b** to **a**.

Section n°1 : take chain **f** and fasten to it two **k**, **L** and the round bell by means of jump rings **c**.

Section n°2 : thread **g** on to a headpin and make a loop at its end using round nose pliers.

Section n°3 : take chain **d** and attach **m** and **n** to it by means of the same jump ring **c**. Thread **h** on to one headpin and make a loop at its end in order to attach it to the chain.

Section n°4 : take chain **e** and then fasten **i** and **J** on to it by means of headpins looped at the end. Attach **o** using one **c**.

Section n°5 : fold the ribbons in half and slot the folded part into end fastener **x**. Hold the section together by flattening **x** using flat nose pliers.

Section n°6 : attach **p** to one **c**.

Attach sections n°1 and 2 to one **b**, n°3 and 4 to one **b**, n°5 and 6 to one **b** (see diagram).

SYLVIA

Length: 7.5cm (3in)

1 mobile phone charm strap (black)

3 x 0.5cm open jump rings **c** (silver)

1 x 1.2cm diameter round bell (silver)

1 square pendant with sides measuring 1.5cm
 (blue and silver)

Attach one **c** to the mobile phone charm strap, then the round bell and pendant to the jump ring using the other two **c** (see diagram).

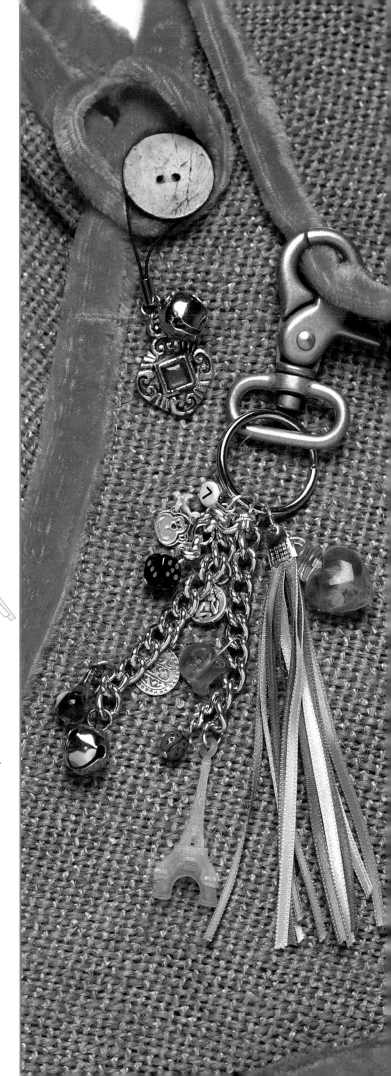

NATALIE

Length: 18cm (7in)

1 x 2.5cm split ring **a** (copper)
1 x 0.6cm open jump ring **b** (copper)
1 x 2.5cm long straight pin (copper)
2 x 0.4cm round beads **c** (copper)
1 x 0.8cm diameter round fancy bead **d** (copper)
1 triangular connector with 5 loops (copper)
5 x 10.5cm long chains (copper)
5 x 1.3cm diameter coin-shaped pendants (copper)

Attach **b** to **a**.
Thread one **c**, **d**, one **c** on to the pin.
Make a loop at each end using round nose pliers. Attach this section to **b**. Fasten the connector to the bottom loop of the pin and fix one chain to each loop of the connector. Attach one pendant to the end of each chain *(see diagram below)*.

YASMIN

Length: 10.5cm (4¼in)

1 mobile phone charm strap (brown)
1 x 0.5cm open jump ring
1 x 2cm long straight pin (copper)
1 x 0.8cm diameter round fancy bead **d** (copper)
1 triangular connector with 5 loops (copper)
5 x 1.5cm long chains (copper)
5 x 1.3cm diameter coin-shaped pendants (copper)

Attach the jump ring to the mobile phone charm strap. Take the pin and thread **d** on to it. Make a loop at each end of the pin. Attach this section to the jump ring and fasten the lower end of the pin to the top of the connector. Next, attach one chain to each loop of the connector. Fix one penda to the end of each chain *(see diagram above)*.

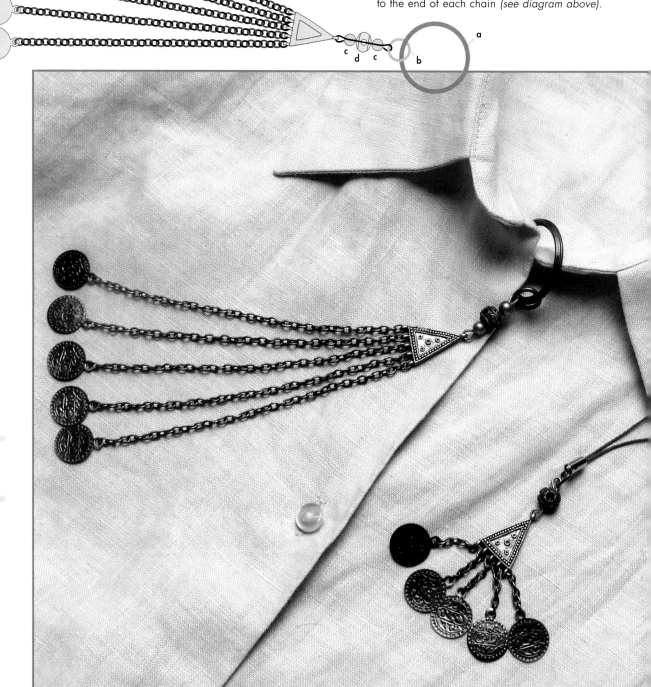

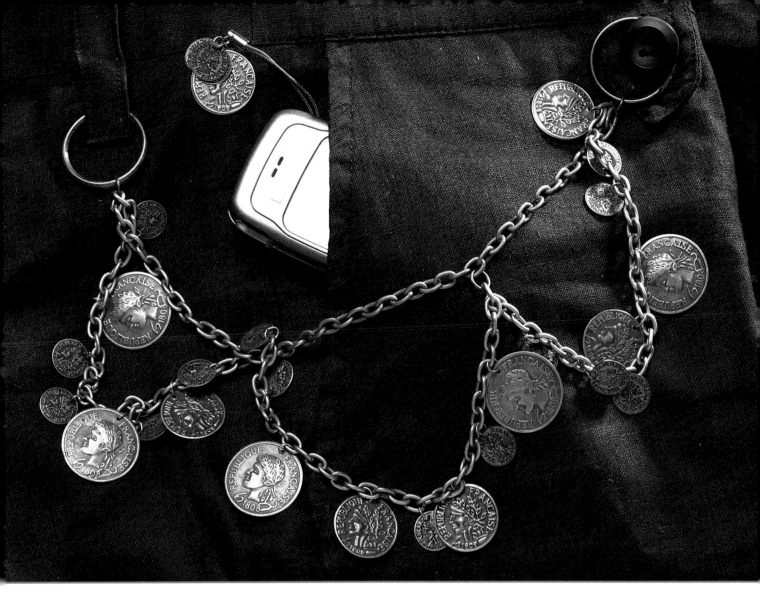

ERNESTINE

Length: 25.5cm (10in)

1 x 68cm long chain (copper)
2 x 2.5cm split rings x (copper)
28 open jump rings (copper):
* 24 x 0.3cm y and 4 x 0.5cm y′*
24 coin-shaped charms:
* 5 x 2.3cm a, 5 x 2cm b, 14 x 1.2cm in diameter c*

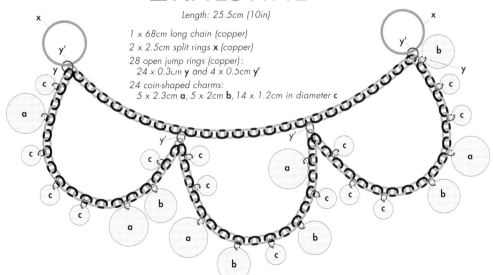

LETITIA

Length: 7cm (2¾in)

1 mobile phone charm strap (brown)
5 open jump rings (copper):
* 4 x 0.3cm y and 1 x 0.5cm y′*
4 coin-shaped charms:
* 1 x 2cm b, 3 x 1.2cm diameter c*

Fold the chain in half.
Join the two strands together at two points using two jump rings y′ so as to form three large loops. Fix split rings x using another two jump rings y′.

Next, attach the 24 charms a, b and c to jump rings y and distribute eight of them evenly along each of the three loops to form the bottom part of the chain.

Attach one jump ring y to each charm and fix them to jump ring y′. Attach this section to the mobile phone charm strap.

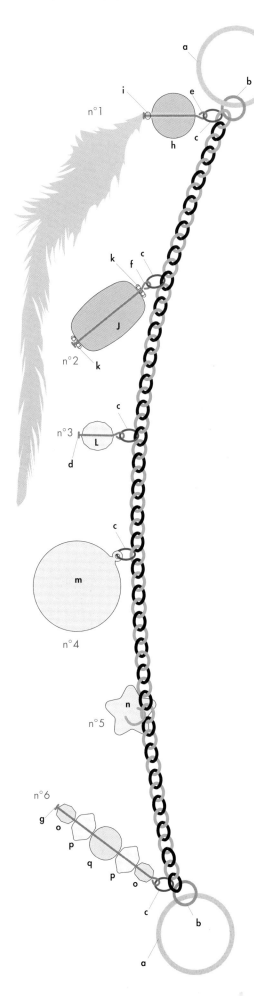

ANASTASIA

Length: 32cm (12½in)

2 x 2.5cm split rings **a** *(copper)*
7 open jump rings *(copper)* : 2 x 0.7cm **b** and 5 x 0.5cm **c**
4 headpins, 2, 2.5, 3.5 and 4cm long **d**, **e**, **f**, **g** *(copper)*
1 x 15cm long feather *(burgundy)*
1 x 26cm long chain *(copper)*
1 x 1.5cm diameter round fancy bead **h** *(amber)*
1 x 0.3cm diameter flat bead **i** *(gold)*
1 cylindrical fancy bead, 2.5cm long and 1.5cm diameter **J** *(amber)*
2 x 0.5cm diameter spacers **k** *(copper)*
3 transparent round faceted beads: 1 x 1cm **L** *(orange)* and 2 x 0.5cm **o** *(amber)*
1 x 3cm diameter coin-shaped charm **m** *(copper)*
1 x 1.5cm long transparent star-shaped faceted charm **n** *(green)*
2 bicone-shaped fancy beads, 0.5cm long and 1cm diameter **p** *(brown and white)*
1 x 1cm transparent round bead **q** *(amber)*

Attach one **b** to one **a** at each end of the chain.

Section n°1 : take headpin **e** and thread it through **i** and **h**.
Make a loop at the end of **e** using round nose pliers. Slide the end of the feather into
beads **i** and **h**.

Section n°2 : take headpin **f**, thread one **k**, **J**, one **k** on to it and make a loop at the end of **f**.

Section n°3 : thread **L** on to headpin **d** and make a loop at the end of **d**.

Section n°4 : attach **m** to one **c**.

Section n°5 : take **n**.

Section n°6 : take headpin **g**, thread one **o**, one **p**, one **q**, one **p**, one **o** on to it and
make a loop at its end. Attach section n°5, using its attachment, and section n°4
to the chain *(see diagram)*.

Attach section n°1, 2, 3 and 6 to the chain using jump rings **c**.

NADIA

Length: 9 cm (3½in)

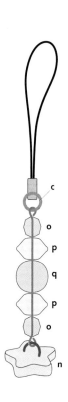

1 mobile phone charm strap *(brown)*
1 x 0.5cm open jump ring **c** *(copper)*
1 x 4.5cm long straight pin *(copper)*
1 x 1.5cm long transparent star-shaped faceted charm **n** *(green)*
2 x 0.5cm diameter transparent round faceted beads **o** *(amber)*
2 bicone-shaped fancy beads, 0.5cm long and 1cm
 diameter **p** *(brown and white)*
1 x 1cm transparent round bead **q** *(amber)*

Attach **c** to the mobile phone charm strap.
Take the straight pin and thread the same beads as
in section n°6 of ANASTASIA *(see above)*.

Make a loop at each end of the straight pin using
round nose pliers. Add **n** and attach the section to **c**.

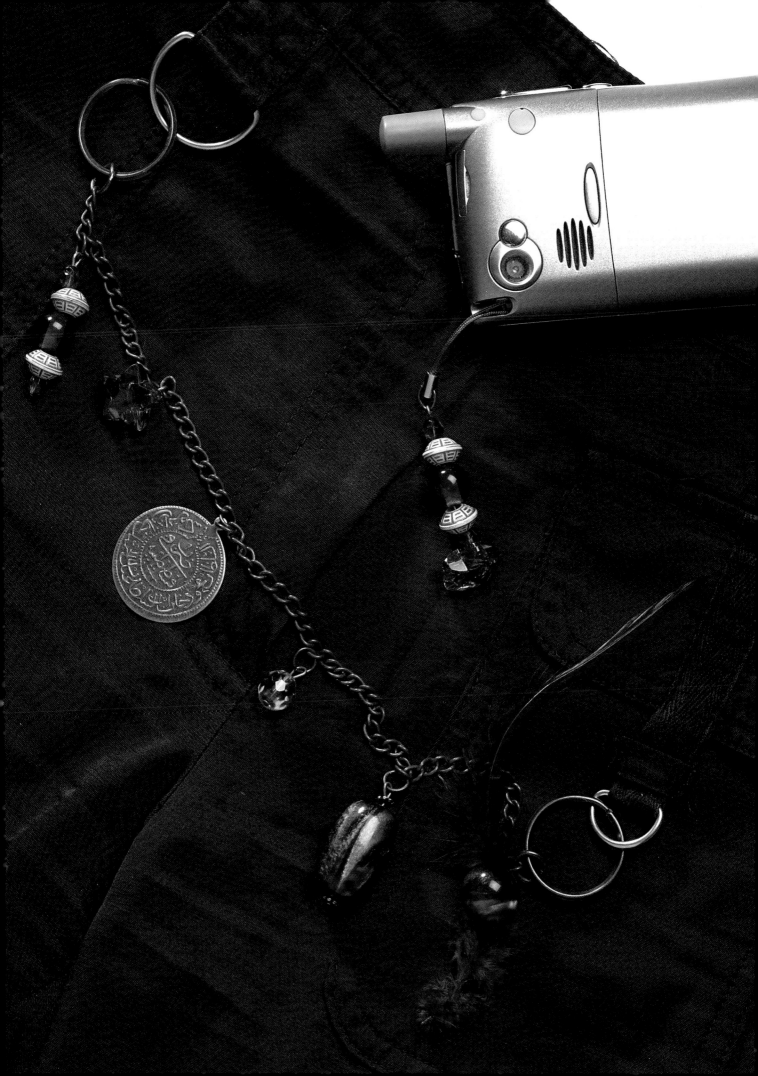

ANNIE

Length: 15cm (6in)

1 x 5.5cm long clasp (copper)
*1 x 2.5cm split ring **a** (copper)*
*13 open jump rings (copper) : 2 x 0.6cm **b**, 2 x 0.5cm **c** and 9 x 0.3cm **d***
*1 x 7cm long leather 'bear' pendant **e** (brown)*
*1 pendant in the shape of a monkey's head **f***
*1 pendant in the shape of a banana **g** (yellow)*
*1 x 1.7cm diameter round fancy charm **h** (yellow and white)*
*1 x 1.5cm long teardrop-shaped fancy charm **i** (blue)*
*2 x 1.3cm long flower-shaped fancy charms (yellow **J**, orange **k**)*
*1 x 1.3cm long olive-shaped fancy charm **L** (dark blue)*
*2 x 1cm diameter round buttons, each with 4 holes (red **m**, pink **n**)*
*1 x 0.7cm long plastic transparent heart-shaped bead **o** (yellow)*
1 x 1.5cm long headpin (copper)
*2 chains, 3 and 7cm long **p**, **q** (copper)*

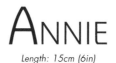
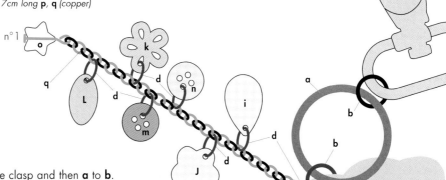

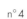

Attach **b** to the clasp and then **a** to **b**.
Section n°1 : take chain **q** and attach **i**, **J**, **n**, **m**,
k, **L** to it using jump rings **d**.
Attach one **d** to one end of the chain and one
o to the other end by means of the headpin, looped
using round nose pliers.
Section n°2 : take chain **p** and attach **g**
and **f** to it by means of two **d**.
Section n°3 : attach **h** to one **c**.
Section n°4 : attach bear **e** to one **b**.
Take one **c** and attach sections n°1, 2, 3 and 4 to it.
Section n°4 is also attached to **a** *(see diagram)*.

TANIA

Length: 10cm (4in)

1 mobile phone charm strap (brown)
*9 open jump rings (copper) : 1 x 0.5cm **c** and 8 x 0.3cm **d***
*1 x 1.7cm diameter round fancy bead **h** (yellow and white)*
*1 x 1.5cm long teardrop-shaped fancy charm **i** (blue)*
*2 x 1.3cm long flower-shaped fancy charms (yellow **J**, orange **k**)*
*1 x 1.3cm long olive-shaped fancy charm **L** (dark blue)*
*2 x 1cm diameter round buttons, each with 4 holes (red **m**, pink **n**)*
*1 x 3cm long chain **p** (copper)*

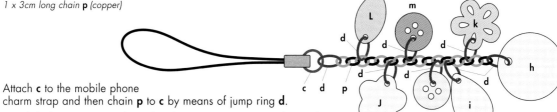

Attach **c** to the mobile phone
charm strap and then chain **p** to **c** by means of jump ring **d**.

Attach **h**, **k**, **i**, **n**, **m**, **J** and **L** to the chain using jump rings **d** *(see diagram)*.

CECILY

Length: 17cm (6¾in)

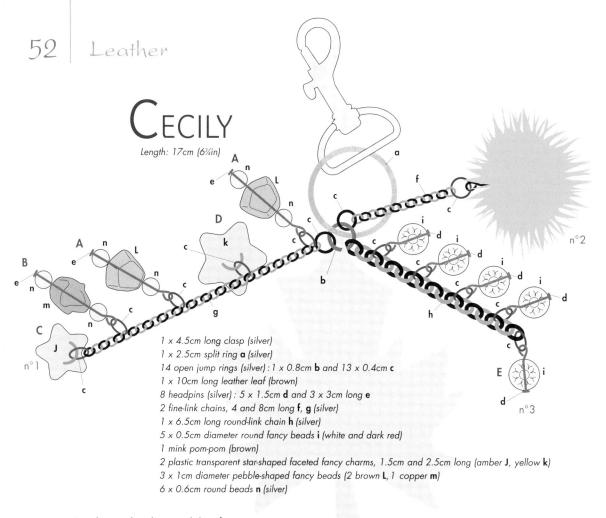

1 x 4.5cm long clasp (silver)
1 x 2.5cm split ring **a** (silver)
14 open jump rings (silver) : 1 x 0.8cm **b** and 13 x 0.4cm **c**
1 x 10cm long leather leaf (brown)
8 headpins (silver) : 5 x 1.5cm **d** and 3 x 3cm long **e**
2 fine-link chains, 4 and 8cm long **f**, **g** (silver)
1 x 6.5cm long round-link chain **h** (silver)
5 x 0.5cm diameter round fancy beads **i** (white and dark red)
1 mink pom-pom (brown)
2 plastic transparent star-shaped faceted fancy charms, 1.5cm and 2.5cm long (amber **J**, yellow **k**)
3 x 1cm diameter pebble-shaped fancy beads (2 brown **L**, 1 copper **m**)
6 x 0.6cm round beads **n** (silver)

Attach **a** to the clasp and then **b** to **a**.
Section n°1 : take one headpin **e**, thread one **n**, one **L**, one **n** on to it and then form a loop at its end using round nose pliers (**A**). Make a second **A** in the same way.
Take one headpin **e**, thread one **n**, **m**, one **n** on to it and then make a loop (**B**).
Attach one **c** on to **J** (**C**) and one on to **k** (**D**).
Fasten the two **A**, **B**, **C** and **D** on to chain **g** with jump rings **c** *(see diagram above)*.

Section n°2 : attach the pom-pom to chain **f** by means of one **c**.
Section n°3 : take headpins **d**, attach one **i** to each of them then make a loop at their ends. Attach these sections (**E**) to chain **h** by means of jump rings **c**.
Attach sections n°1 and n°2 to **b** by means of one **c**.
Attach section n°3 directly to **b**.

Make a hole in the leaf and attach it to **b**.

Note

You can find pre-cut leaf shapes in some leather goods shops. You can also make them yourself by cutting the leaf out of rigid shoe-making leather.

NATASHA

Length: 8.5cm (3½in)

1 mobile phone charm strap (brown)
3 x 0.4cm open jump rings **c** (silver)
4 x 1.5cm long headpins **d** (silver)
4 x 1.5cm long straight pins (silver)
1 x 2cm long round-link chain **h** (silver)
4 x 0.5cm diameter round fancy beads **i** (white and dark red)
2 x 1.5cm long plastic, transparent, star-shaped, faceted fancy charms **J** (amber)
4 x 0.6cm round beads **n** (silver)

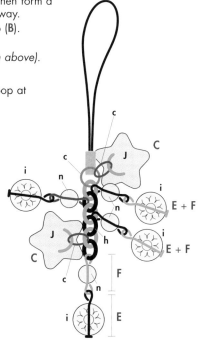

Attach one **c** to the mobile phone charm strap, then chain **h** to **c**.
Attach one **n** to each pin and then make a loop at each end using round nose pliers (**F**).

Make four **E** *(see CECILY above)* and then attach one to each **F**. Attach each of these sections to chain **h**.

Make two **C** *(see CECILY)*. Attach them to **h** by means of jump rings **c** *(see diagram)*.

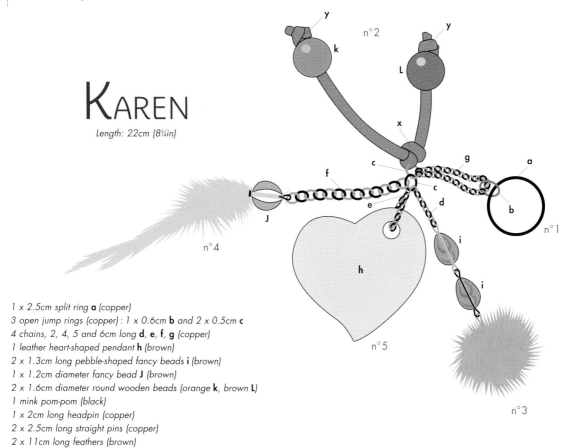

KAREN

Length: 22cm (8¾in)

1 x 2.5cm split ring **a** (copper)
3 open jump rings (copper) : 1 x 0.6cm **b** and 2 x 0.5cm **c**
4 chains, 2, 4, 5 and 6cm long **d**, **e**, **f**, **g** (copper)
1 leather heart-shaped pendant **h** (brown)
2 x 1.3cm long pebble-shaped fancy beads **i** (brown)
1 x 1.2cm diameter fancy bead **J** (brown)
2 x 1.6cm diameter round wooden beads (orange **k**, brown **L**)
1 mink pom-pom (black)
1 x 2cm long headpin (copper)
2 x 2.5cm long straight pins (copper)
2 x 11cm long feathers (brown)
1 x 20cm long leather thong (red)

Section n°1 : attach **b** to **a**, then chain **g** folded in half to **b**.

Section n°2 : make a knot **x** in the middle of the thong, then thread **k** and **L** on to it, fixing them with a knot **y** at each end of the thong.

Section n°3 : thread two **i** on to the two pins then make a loop at each end using round nose pliers. Link these two pieces then add chain **d** and the pom-pom.

Section n°4 : slip **J** on to the headpin then make a loop at the end. Attach this section to one end of chain **f** then slide the two feathers into **J**.

Section n°5 : attach **h** to chain **e** folded in half.

Link the two **c** together then attach n°1 and 2 to one **c** and n°3, 4, 5 to the second **c** *(see diagram above)*.

ZOE

Length: 14cm (5½in)

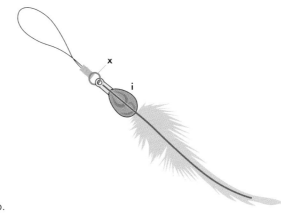

1 mobile phone charm strap (brown)
1 x 0.5cm open jump ring **x** (silver)
1 x 1.3cm long pebble-shaped fancy bead **i** (brown)
1 x 11cm long feather (brown)
1 end fastener (copper)

Attach jump ring **x** to the mobile phone charm strap.
Thread the feather into **i** then place the end fastener on the end of the feather and flatten it using flat nose pliers.
Apply a dot of glue to hold the section together and then attach it to jump ring **x**.

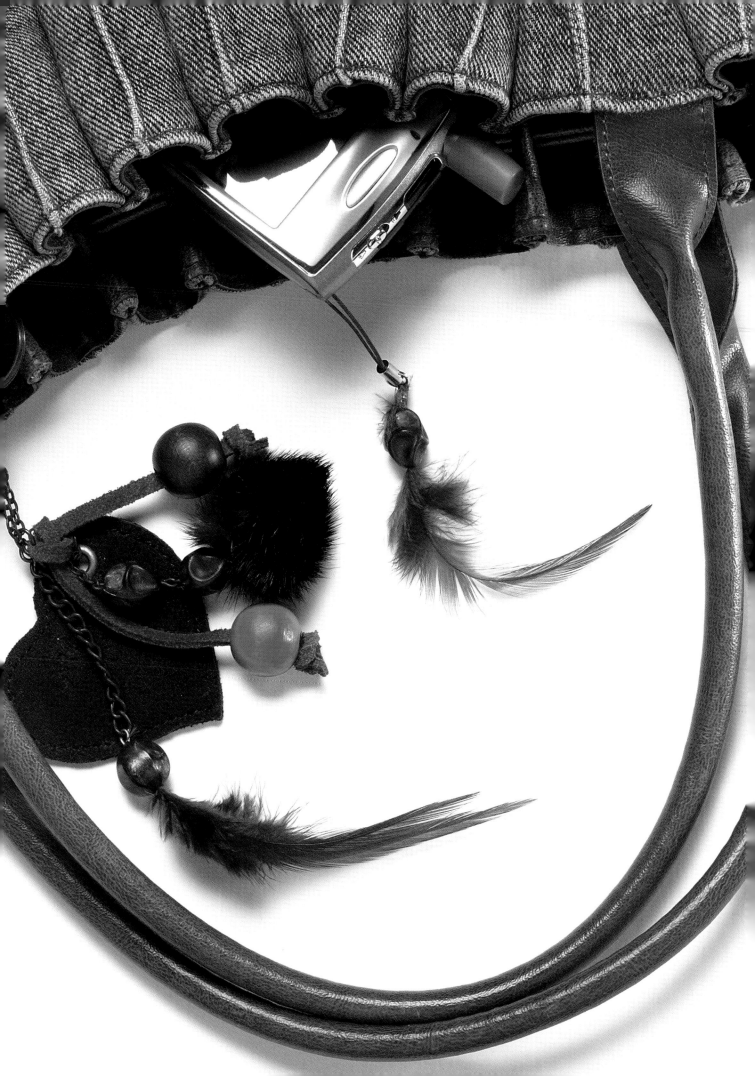

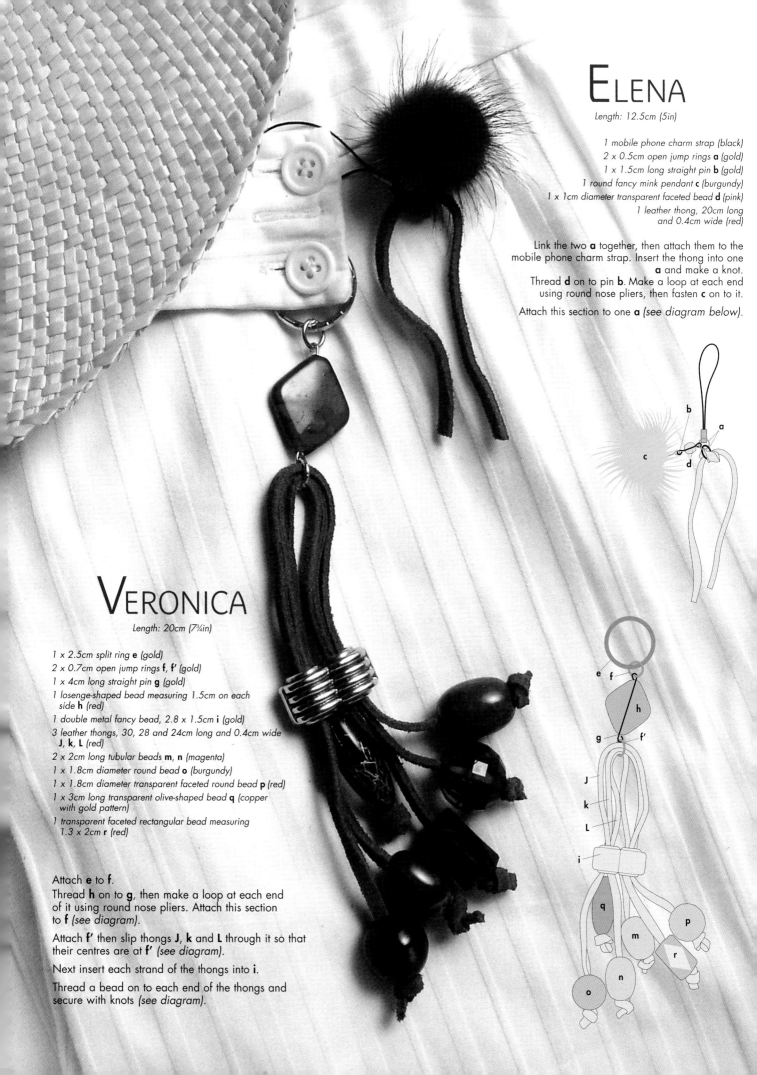

ELENA

Length: 12.5cm (5in)

1 mobile phone charm strap (black)
2 x 0.5cm open jump rings **a** (gold)
1 x 1.5cm long straight pin **b** (gold)
1 round fancy mink pendant **c** (burgundy)
1 x 1cm diameter transparent faceted bead **d** (pink)
1 leather thong, 20cm long
and 0.4cm wide (red)

Link the two **a** together, then attach them to the mobile phone charm strap. Insert the thong into one **a** and make a knot.
Thread **d** on to pin **b**. Make a loop at each end using round nose pliers, then fasten **c** on to it.

Attach this section to one **a** *(see diagram below)*.

VERONICA

Length: 20cm (7¾in)

1 x 2.5cm split ring **e** (gold)
2 x 0.7cm open jump rings **f**, **f'** (gold)
1 x 4cm long straight pin **g** (gold)
1 losenge-shaped bead measuring 1.5cm on each side **h** (red)
1 double metal fancy bead, 2.8 x 1.5cm **i** (gold)
3 leather thongs, 30, 28 and 24cm long and 0.4cm wide **J**, **k**, **L** (red)
2 x 2cm long tubular beads **m**, **n** (magenta)
1 x 1.8cm diameter round bead **o** (burgundy)
1 x 1.8cm diameter transparent faceted round bead **p** (red)
1 x 3cm long transparent olive-shaped bead **q** (copper with gold pattern)
1 transparent faceted rectangular bead measuring 1.3 x 2cm **r** (red)

Attach **e** to **f**.

Thread **h** on to **g**, then make a loop at each end of it using round nose pliers. Attach this section to **f** *(see diagram)*.

Attach **f'** then slip thongs **J**, **k** and **L** through it so that their centres are at **f'** *(see diagram)*.

Next insert each strand of the thongs into **i**.

Thread a bead on to each end of the thongs and secure with knots *(see diagram)*.

SANDRA

Length: 17cm (6¾in)

1 x 3.5cm long clasp (gold)
1 x 2.5cm split ring **a** (gold)
2 x 0.5cm open jump rings **b** (gold)
3 mink pom-poms (brown)
3 chains with different-sized links,
 1.5, 5 and 10cm long **c**, **d**, **e** (gold)

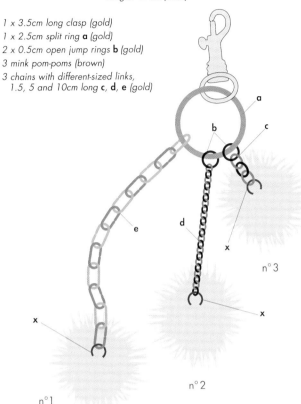

n°1

n°2

n°3

Attach **a** to the clasp.
Section n°1 : fix one end of chain **e** to attachment **x**
of one pom-pom.
Section n°2 : attach one end of chain **d** to attachment **x** of one
pom-pom and fix one jump ring **b** to the other end.
Section n°3 : attach one end of chain **c** to attachment **x** of one
pom-pom and fix one jump ring **b** to the other end.
Attach sections n°1, 2 and 3 to **a** *(see diagram above)*.

VALERIE

Length: 9.5cm (3¾in)

1 mobile phone charm strap (brown)
1 x 0.5cm open jump ring **x** (gold)
1 x 3cm long chain (gold)
1 mink pom-pom (brown)

Attach the jump ring to the mobile phone
charm strap, then the chain to jump ring **x**
and finally the pom-pom to the chain.

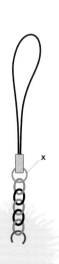

Note

Mink pom-poms with a ready-made hole and
loop attachment are available commercially.
If you are unable to find them with an
attachment, you can always make them
yourself using a straight pin.

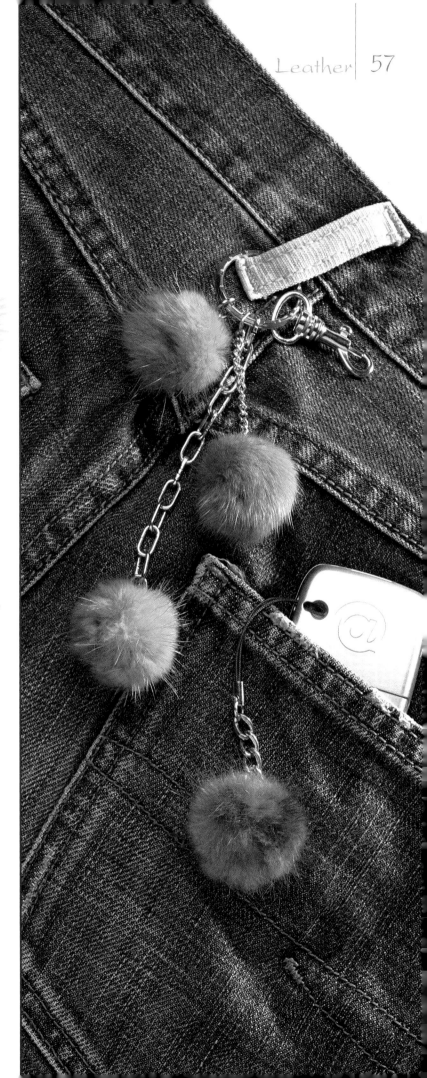

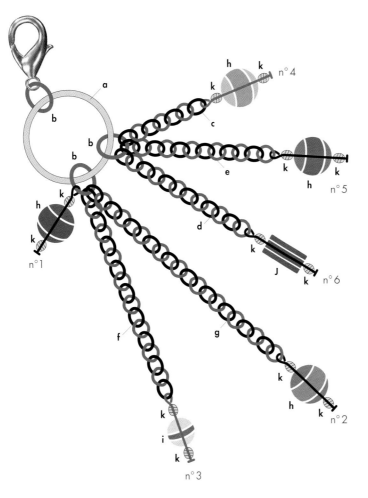

CHERYL

Length: 15cm (6in)

1 x 2cm long clasp (gold)
*1 x 2.5cm split ring **a** (gold)*
*3 x 0.6cm open jump rings **b** (gold)*
*5 chains: 3cm **c**, 4cm **d**, 5cm **e**, 6.5cm **f** and 7.5cm **g** (gold)*
6 x 2.5cm long headpins (gold)
*5 round fancy beads (multicoloured) : 4 x 1.2cm diameter **h** and 1 x 1cm diameter **i***
*1 rectangular fancy bead, 0.7 x 1.5cm **J** (multicoloured)*
*12 x 0.3cm diameter ridged beads **k** (gold)*

Attach one jump ring **b** to the clasp, then split ring **a** to **b**.

Take the other jump ring **b** and attach it to chains **f** and **g**.

Sections n°1 and n°2 : thread one **k**, one **h**, one **k** on to each of two headpins. Make a loop at their ends using round nose pliers. Attach section n°1 to **b** and n°2 to **g**.

Section n°3 : take a third headpin and thread one **k**, **i**, one **k** on it and make a loop. Attach this section to **f**.

Attach **b** to **a**.

Take one jump ring **b** and attach chains **c**, **d** and **e** to it.

Sections n°4 and n°5 : thread one **k**, one **h**, one **k** on to each of two headpins. Make a loop. Attach section n°4 to **c** and n°5 to **e**.

Section n°6 : take the last headpin and thread one **k**, **J**, one **k** on it, then make a loop. Attach this section to **d**.

Fix jump ring **b**, linking sections n°4, 5 and 6 to split ring **a**.

CLEMENTINE

Length: 11cm (4¼in)

1 mobile phone charm strap (red)
*2 x 0.6cm open jump rings **b** (gold)*
1 x 3.5cm long straight pin (gold)
2 x 2.5cm long headpins (gold)
*2 x 1cm diameter round fancy beads **i** (multicoloured)*
*1 rectangular fancy bead, 0.7 x 1.5cm **J** (multicoloured)*
*4 x 0.3cm diameter ridged beads **k** (gold)*
*4 chain links **L** (gold)*

Attach one jump ring **b** to the mobile phone charm strap, then two **L** to **b**.

Take the straight pin and thread **J** on to it. Make a loop at each end using round nose pliers and attach this section to the last link **L**.

Attach two **L** and one jump ring **b** to the other end.

Attach one **k**, one **i**, one **k** to each of the two headpins. Make a loop in the ends of the pins and attach them to the last jump ring **b** *(see diagram)*.

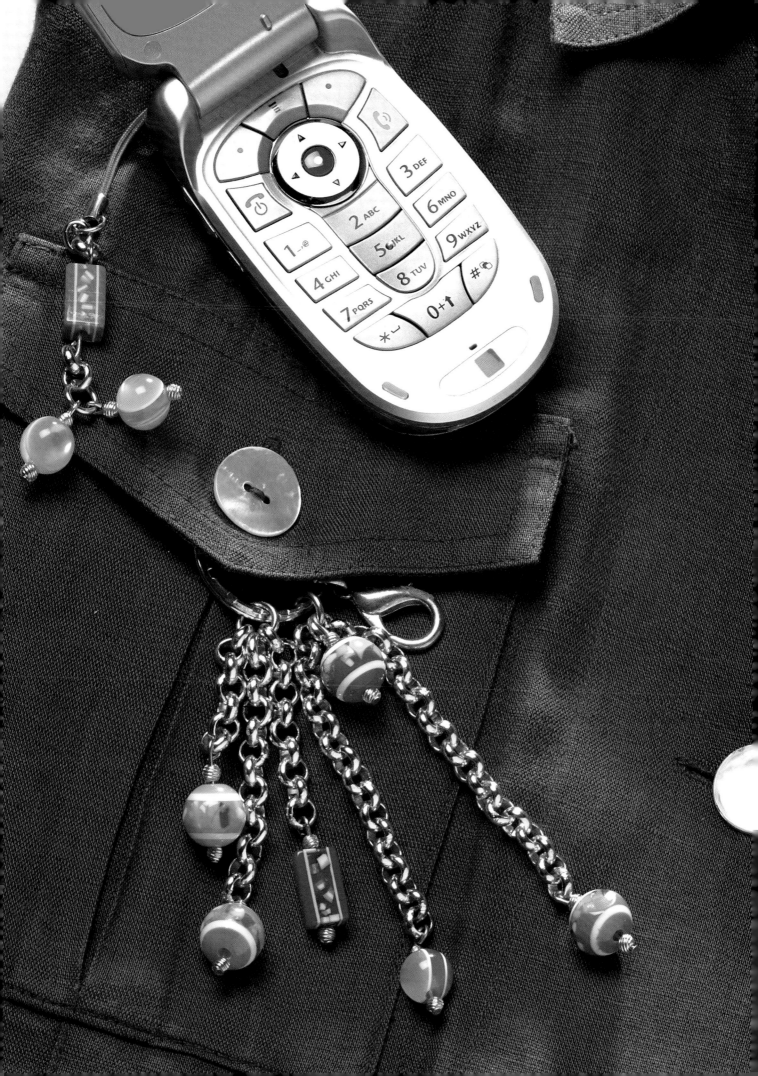

MARIA

Length: 21cm (8¼in)

1 x 5cm long clasp (gold)
1 x 2.5cm split ring **a** (gold)
10 open jump rings (gold): 2 x 1cm **b** and 8 x 0.5cm **c**
1 x 4cm long large-link chain **d** (gold)
2 fine-link chains, 3 and 8cm long (gold)
6 x 1cm diameter round bells (gold)
1 felt angel (red)

Fix **b** to the clasp, then **a** to **b**.

Attach chain **d** to **a**, then the second **b** to this chain. Fasten the angel on to **b**.

Attach the other two chains to **b** using two **c**.

Attach the six round bells to these chains using the other six **c**.

Note

The angel is a Christmas tree decoration.

You can also make it yourself by cutting the shape out from a piece of thick felt.

Don't forget to add an eyelet to strengthen the attachment hole.

DEBORAH

Length: 9cm (3½in)

1 mobile phone charm strap (red)
1 x 0.7cm closed jump ring (silver)
2 x 2cm long straight pins (gold)
1 x 1cm diameter round bell (gold)
2 x 0.8cm diameter fancy beads (red)

Fix the closed jump ring to the mobile phone charm strap.

Take the two pins and thread one red bead on to each.

Make a loop at each end of the pins using round nose pliers.

Link the two pins and attach this section to the closed jump ring. Add the round bell *(see photo below)*.

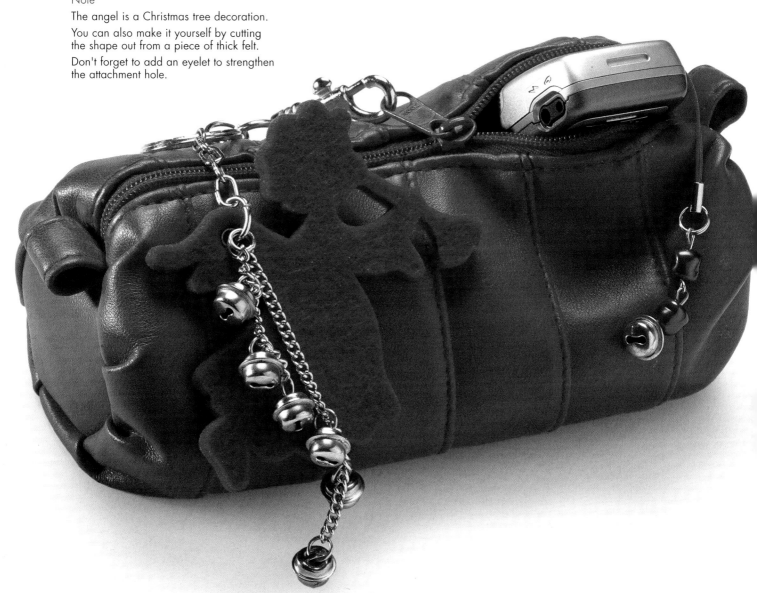

PENNY

Length: 7.5cm (3in)

CHARLOTTE

Length: 13cm (5in)

1 x 7.5cm long kilt pin with 4 loops (gold)
3 headpins, 3, 3.5 and 5cm long **a**, **b**, **c** (gold)
1 x 3.5cm long straight pin **d** (gold)
1 cylindrical bead with flower pattern,1.5cm long and 1cm diameter **e**
5 satin beads (red) : 4 x 0.4cm **f** and 1 x 0.6cm diameter **g**
2 x 1.5cm long transparent olive-shaped beads **h** (red)
1 x 1.3cm wide octagonal bead with flower pattern **i**
1 x 1cm long oval bead with flower pattern **J**
1 teardrop-shaped bead, 0.7cm long and 0.5cm diameter **k** (yellow)
1 x 0.6cm closed jump ring **x** (gold)
1 cubic bead measuring 0.4cm on each side **L** (red)
1 square-shaped satin bead measuring 1cm on each side **m** (red)
1 x 0.7cm round bead **n** (red with black and white pattern)
1 x 0.8cm diameter round cat's eye bead **o** (red)

1 mobile phone charm strap (black)
1 x 0.5cm open jump ring **x** (gold)
2 straight pins, 2 and 2.5cm long **p**, **q** (gold)
1 cubic bead with flower pattern measuring
0.7cm on each side **r** (red)
1 transparent square-shaped bead with sides
measuring 0.5cm **s** (magenta)
2 x 0.3cm round beads **t** (gold)
1 'tassel' charm **u** (red)

Take headpin **b** and thread **L**, **m**, **n**, **g** and **o** on it.
Make a loop at the end using round nose pliers.

Take straight pin **d** and thread on to it one **f**, **i**, one **f**. Make a loop at each end.

Attach closed jump ring **x** to one end and fasten **k** to it.

Take headpin **c** and thread one **h**, **J**, one **h** on to it. Make a loop at the end.

Take the last headpin **a**, thread one **f**, **e**, one **f** on to it and make a loop.

Finally attach each piece to the pin *(see diagram)*.

Attach jump ring **x** to the mobile
phone charm strap.

Take straight pin **p** and thread **r** on it. Make a
loop at each end using round nose pliers.

Take pin **q** and thread one **t**, **s**, one **t** on it.
Make a loop at each end.

Link pins **p** and **q** and attach them to ring **x**.
Finish by attaching charm **u** to the end pin *(see diagram)*.

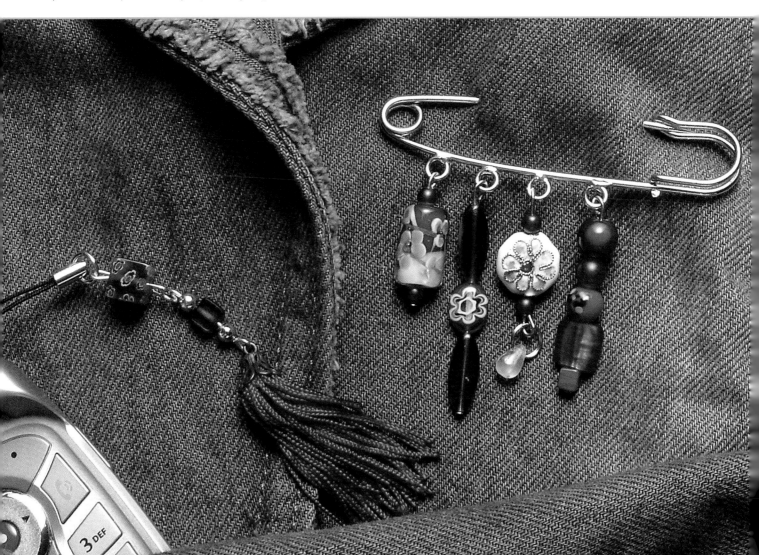

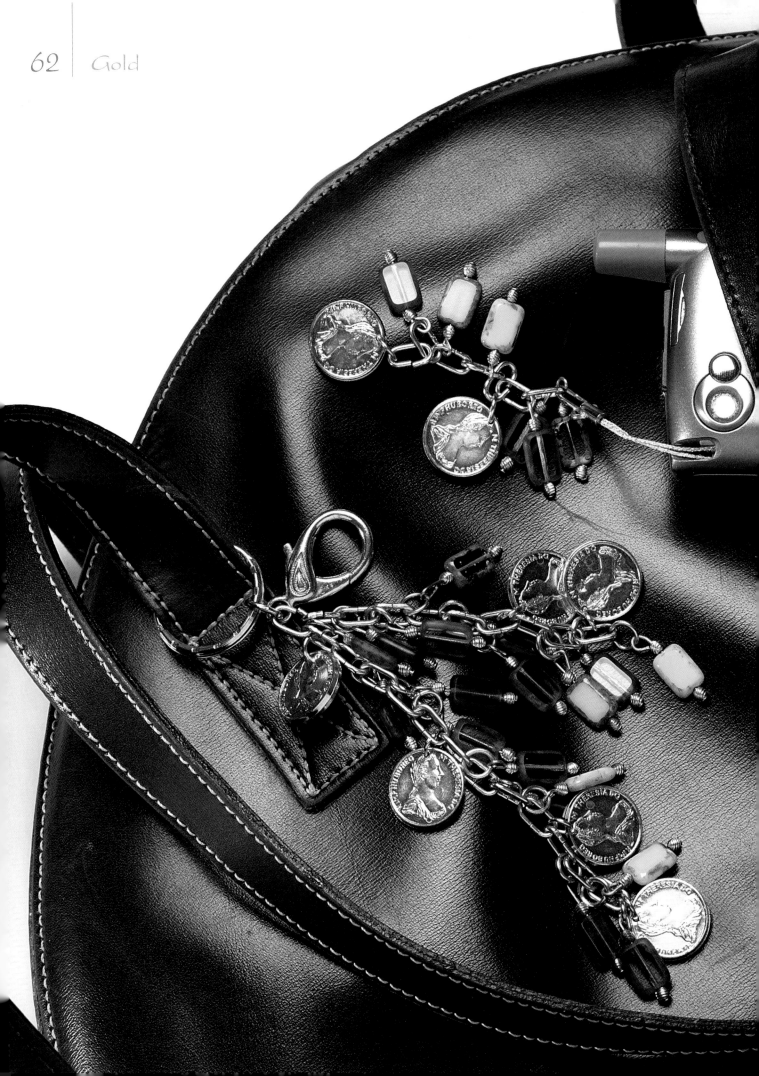

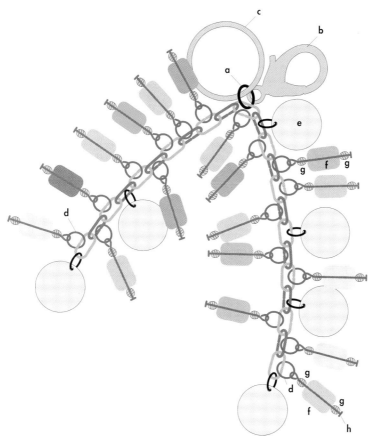

OCTAVIA

Length: 22cm (8¾in)

25 open jump rings (gold): 1 x 0.7cm **a**
and 24 x 0.5cm **d**
1 x 3cm long clasp **b** (gold)
1 x 2.2cm split ring **c** (gold)
1 x 17cm long chain (gold)
6 x 1.7cm diameter coins **e** (gold)
18 x 1cm long rectangular beads of different
colours **f**
36 x 0.3cm diameter ridged beads **g** (gold)
18 x 2.5cm long headpins **h** (gold)

Attach jump ring **a** to the chain 7cm (2¾in)
from one end. Fix **b** and **c** on to **a**.

Take headpins **h** and string one **g**,
one **f** and one **g** on to each of them.
Make a loop at the end of each headpin
and attach the section to jump ring **d**
and then to the chain *(see diagram)*.

Take each **e**, fix one **d** on to it and
attach the section as shown in the
diagram.

AMY

Length: 12.5cm (5in)

1 mobile phone charm strap (yellow and silver)
3 x 0.5cm open jump rings **a** (gold)
1 x 6cm long chain (gold)
2 x 1.7cm diameter coins **e** (gold)
6 x 1cm long rectangular beads of different colours **f**
12 x 0.3cm diameter ridged beads **g** (gold)
6 x 2.5cm long headpins (gold)

Attach one jump ring **a** to the mobile phone
charm strap and to one end of the chain.

Take the six headpins and string one **g**, one **f**
and one **g** on to each of them. Make a loop
at the end of each headpin.

Take both **e** and fix one **a** on to each of them.

Attach each section to the chain as shown
in the diagram.

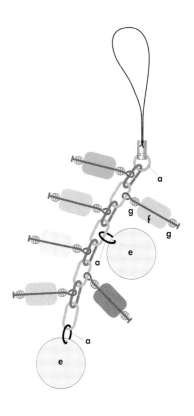

First published in Great Britain 2007 by Search Press Limited,

Wellwood, North Farm Road, Tunbridge Wells, Kent TN2 3DR

Originally published in France 2006 by Éditions Didier Carpentier

Copyright © Éditions Didier Carpentier

English translation by Cicero Translations

English translation copyright © Search Press Limited 2007

English edition edited and typeset by GreenGate Publishing Services, Tonbridge, Kent

ISBN-10: 1-84448-279-0

ISBN-13: 978-1-84448-279-5